# ROGER WATERS' PHILOSOPHY OF ROCK

搖滾哲思 OF ROCK

吳駘締、敖采渝

著

# 序

　　2017 年 6 月我因受邀於美國 Art Fusion Galleries，得有幸代表台灣參加了國際性的世界畫展。7 月 9 日畫廊舉辦了開幕酒會。Art Fusion Galleries 位於佛羅里達州的邁阿密，這是個世界認評比最優之一的畫廊，我很榮幸受邀前與參展。我與世界各國當代知名畫家，雕塑家共來自 46 個國家，76 位藝術家互相切磋琢磨，了解彼此創作的理念與技巧，可謂收穫相當大，與有榮焉。希望也有讓世界看到了台灣。當時接受了畫廊的專訪，談及我的畫作屬於哲學思考的創作，與一般的純粹藝術較為不同，但今天我所討論的是「哲學搖滾大師 Roger Waters 的哲思作品」，在我受邀參與畫展時，我正好查了 Roger Waters 演唱會的時程表，就這麼巧我這次的美國行程，第一站邁阿密，而 Roger Waters 也剛好在邁阿密有一場演唱會，在 American Air Line Arena，於是我訂了演唱會的票，第二站我會到北卡羅萊納州 Roger Waters 正好 Greesbero 也有一場，第三場在 Philadapia 的 Wells Fargo 我訂了距離他最近的位置。同時安排船運公司將十七幅畫作運往邁阿密參加 Art Fusion Galleries 舉辦的畫展。我從六歲，當時還是幼稚園時的階段，我就愛上

了 Pink Floyd 這個樂團。1965 年的 Pink Floyd 是由 Syd Barrett 為首，Roger Waters 是當時的 bass 手，主要曲子由 Syd 來完成，Syd Barrett 因為使用藥物過量而離團，之後樂團的重心就來到了 Roger Waters 的身上，在 1975 年《*Wish You Were Here*》的〈Shine on Your Crazy Diamond〉裡提到懷念 Syd 的曲子。鑽石是地球神話的一部分，Syd 是 Roger Waters 生命中的一部分，世界上真正美好的事都具有獨特性。

在美國我總共聽了 Roger Waters 的三場演唱會，場場精彩萬分以下是演唱會的時間序：

7/18　MIAMI - AMERICAN AIRLINE ARENA

7/28　NORTH CAROLINA - GREENSBERORO ARENA

8/8　PHILADAPIA - WELLS FARGO ARENA 4

9/21　NEW YOUR - NEW YORK ARENA

在每一場的演唱會結束前他會走下舞台和觀眾握手，握到這個手可是非常的不容易，我穿著一雙經歷風霜的運動鞋，踩過多少美國人的腳甚至膝蓋大腿喊著 ROGER！ROGER！ROGER！他終於聽到我的呼喊，朝我走了過來。我終於如願以償握到他的手並擊掌！！！！！

我告訴他我來自台灣，將會寫一本與他以及他的作品集有關的專書，他高興的說 MAIL ME ONE！！！！！

我是以頂禮膜拜的心態去聽這位我從六歲就開始迷戀的樂團的靈魂人物，他的演出令人震懾，內心油然地肅然起敬，當他雙手用力拍著自己的心臟處，再將雙手臂伸向觀眾，他知道他是一位被朝聖者。他是那麼愛支持他音樂的樂迷們。

2017 年 10 月　寫於美國北卡

# 搖滾哲思
## *Roger Waters' Philosophy of Rock*

*Fearless*

Chapter *01*

── 永不懼怕的巨人

Richie Unterberger（樂評人）讚嘆道「沒有任何一個時代能像 Pink Floyd 所創造的時代那樣偉大！」

Roger Waters 出生於 1943 年 9 月 6 日，小時候的 Roger 遭受炸彈如雨下的恐慌。1940 年的 9 月至 11 月，在布克漢（Great Bookham），Roger 與家人所居住的城市，遭受到了攻擊，炸彈炸毀了整條街巷，偏遠村莊及首都都成為了攻擊的目標。Roger 的母親 Mary Whyte，是名蘇格蘭人，父親名為 Eric Flectcher Waters 是一位學校老師，他所教授的是宗教及體育，英國北方

人，年輕時加入了青年團及童子軍，擁有著非常好的德行與美德。他所居住的地方稱作為布拉福（Bradford），附近有一礦場，即使當時國家把上戰場此行為誇口是件偉大的事件，然而這個地區沒有一個人是自願當政治人物或是前往戰場的。

Roger 的父親，Eric 原本是可逃離戰役的，但 Eric 的父親是一個礦工，他有著暴躁的脾氣，強大的威權性格帶給了 Eric 極大的壓力。

在布拉福地區，礦工們是沒有自己的意見的，當時的人們所想的僅僅只要能溫飽就好。他們當時覺得共產是件好事，對他們來說不用愁吃穿，有食物即可，共產主義的想法讓 Eric 並不想參與戰爭，然而此時的德國納粹攻佔了波蘭，而蘇聯則進攻了芬蘭，在德軍陸續攻佔歐洲各國之後，英國成為了納粹覬覦的一塊寶地。

Eric Waters 當時被招募擔當救護車的司機，他心想，這樣或許可以避開上戰場，但救護車卻永遠是站在最前線的，哪裡需要他，他總是必須第一個衝進去。

Eric 在戰場裡看到了許多傷兵，他決定加入戰場成了自願兵，他參與了英國皇家弗希樂步兵兵團（Fussilers），1 月 22 日他的戰隊首先在義大利的安濟奧登陸，此地為距離 Peter Beach 六英哩的地方，戰爭隨之在安濟奧[1]展開，此戰役也稱為

---

[1] 安濟奧是座義大利沿海城市，在羅馬市南邊 33 英哩，以海邊艇靠港灣知名，曾經是歷史上第二次世界大戰盟軍關鍵的義大利戰役登陸戰地點。

鵝卵石行動，為英美兩國聯合對義大利的登陸行動，意圖在於包抄德國在義大利的冬季防線[2]。

安濟奧成了血腥的戰場，與英軍交戰的德軍，14 陸軍則一舉殲滅了當時的英軍，而軍號為 292975 的 Eric 則被報告死於 1944 年 2 月 18 日，英軍只參戰了三星期，Eric 便因戰而亡。Roger 就像其他小孩一樣在戰爭的恐懼中被養大，他們的夜晚被如雨落下的炸彈籠罩著，他們躲在防空洞裡躲過無數的日夜，空襲警報的聲響澈底得響著，他的媽媽，用雙手捲抱著 John 與 Roger，但對 Roger 來說，他的情緒 DNA 從此注入了他的威權人格，因為他的童年是如此度過的。Roger 的媽媽在這樣的時代背景，決定站出來獨自撫養這兩個小孩，他申請了學校的教師職務，他們則搬到了 42 Rock Road，而屋子的名字叫 Fleetwood。無巧不成書，Rock Road 的住址之後竟然讓 Roger 成了偉大的搖滾音樂家。Roger 的媽媽騎著腳踏車沿著河岸就可到達學校，而他們居住的地方（Grant Chester Meadows）因被英國保護的非常周全，也因此成了當時最美的與那可以供兒童嬉戲的地方。

戰爭並未停止，反而更加的劇烈，看著其他家庭的爸爸們陸陸續續地回家，Roger 的家庭所收到的是一封來自當時英國國王喬治五世，一封感念 Eric Fletcher Waters 為國犧牲的信。

---

[2] 冬季防線為二戰時期，德國與義大利在義大利所設下一系列的軍事防禦工事。

Roger 的童年時代，對於父親的一切很好奇，他穿著他爸爸穿過的軍服，他媽媽把這件衣服保留在他的衣櫥裡，他一讀再讀那封捎來他爸爸死訊的信，他從相簿裡去找到他爸爸與他那曾有的快樂時光，他向哥哥與母親詢問有關於他爸爸所留下任何值得紀念的事物，而這位父親對這位未來的音樂家有著莫大的影響。

1947 年的 9 月，他度過了他的四歲生日，之後他進入了在 Blinco Rd. 的 Morley Memorial Junior School 就學，這個學校就在他家的街角。

七年後他們搬到了 Hills Rd.，這是個重要的階段，他進入了 Cambridgeshire High School 藝術班級課程就讀，在 Honerton 大學，也是在此時，他發展了早期藝術成形的青年時期，也造就了他的未來。

在初中時期，Roger 認識了 Syd Barrett 和 David Gilmour，對於 1954 年 Roger Waters 在 Cambridgeshire 就讀的時期，我們可以從《The Wall》專輯中〈Another Brick in the Wall〉（Part 2）看到 Roger 是如何描寫他接受的教育，當時的老師是 William Eagling，他是以嚴厲出名的教師，而這所學校也是以嚴厲的教學而名聲大噪，在校的學生所期盼的便是能夠像在維多莉亞中學的學生一樣受開放式教育（維多莉亞中學擁有較為開放式的教學風格），但 Roger 進入的學校則是以貶低代替啟發、責罵代替鼓勵，導致在他的成長黃金時期所接受到的是壓迫式教

育，這兒的學生無法順著自己的心聲來學習。

1962 年三個人，Roger Waters、Syd Barrett、David Gilmour 在大學時，所學的領域分別是：Syd 所主修是藝術與科技（Arts and Technology），David 主修語言，而 Roger 卻離開了 Cambridge，跑去唸了建築。1962-1964 之間，Syd 創造了不同的音樂領域，1964 年他們所組的樂團其名稱 Those Without 來自於 1957 年的小說 *Those Without Shadows*，此小說攜帶著法國存在主義的思維。

David 參與了很多樂團的演出，包括 New Comers 以及 The Ramblers，之後加入藍調搖滾 Jokers Wild 樂團。Roger Waters 在 1963 的秋天，正式成為 Sigma 6 的團員，當時 Roger 還在學建築設計，在 Regent Street Polytechnic 蓋房子，他說：「I suppose we formed several groups there」。

Pink Floyd 的迷幻色彩主義從 1967 年的《*The Piper at the Gates of Dawn*》及 1968 年的《*A Saucerful of Secrets*》這兩張作品開始，為 Syd Barrett 在團時所呈現的風格。

1969 年起樂團就改由 Roger Waters 做為主導，實驗性色彩仍非常的濃厚，第三張作品的發行為 1969 年的《*Music From the Film More*》（為電影做的配樂）；第四張於 1969 年製作的《*Ummagumma*》嘗試了大量的樂器實驗，希望運用錄音技巧及吉他的特殊彈奏法模擬出海豚、鯨魚及海底世界的概念專

輯，這一首曲子就長達快一小時，無法領會的人，真不知道他們在做什麼，其實聽者要隨著他們的實驗勇氣，加上想像力去聽出他們所努力營造出的海底巡禮。

《Ummagumma》單一首曲子就長達五十一分二十秒，非常精彩地演出蘊藏深深海底的柔軟光輝。1970 年的《Atom Heart Mother》、1971 年的《Meddle》及 1972 的《Obscured by Clouds》都還是充滿迷幻及實驗性的作品，而這些專輯 Roger Waters 掌握了大部分的錄音工程。

我們回到 Syd 的時代來看，當時 Syd 所營造的效果，時而詭譎、時而像莊園的田園風格，如《The Piper at the Gates of Dawn》，這張專輯的概念是取自 Syd 最喜歡的童書 The Wind and the Willows，於 1967 年 1 月發行的首張單曲，第一首曲子〈Arnold Layne Candy and Current Ban〉，曲長 2 分 53 秒。

## ARNOLD LAYNE CANDY AND CURRANT BAN

### Musicians

Syd Barrett: vocal, backing vocals, electric guitar, acoustic guitar

Roger Waters: bass, backing vocals

[Lyrics]

Arnold Layne had a strange hobby

Collecting clothes

Moonshine washing line

They suit him fine

On the wall hung a tall mirror

Distorted view, see through baby blue

He done it

[Chorus]

Oh, Arnold Layne

It's not the same, takes two to know

Two to know, two to know

Two to know

Why can't you see?

Arnold Layne

Arnold Layne

Arnold Layne

[Verse 2]

Now he's caught - a nasty sort of person

They gave him time

Doors bang, chain gang

He hates it

[Chorus]

Oh, Arnold Layne

It's not the same, takes two to know

Two to know, two to know

Two to know

Why can't you see?

Arnold Layne

Arnold Layne

Arnold Layne

Arnold Layne

Don't do it again

　　初創那時，1967 年的一月底二月初他們錄製了〈Interstellar Overdrive〉由 EMI 發行，這首曲子原為十分鐘長，但為了商業考量，他們必須把它縮減成 2 分 53 秒的作品。

　　Syd 是 Pink Floyd 的原創人，他於 1967 年一月二十在 UFO 俱樂部表演時使用 Danelectro 3021 型號的吉他演奏，Roger Waters 在 Arnold Layne 這首曲子裡用了 Rickenbacker 4001S 型號的貝斯演奏。Roger Water 在 2006 年的一場演唱會上演唱了這首曲子〈Arnold Layne〉。這場演唱結合了 Richard Wright、David Gilmour 共同演出。

David Bowie 在 2006 年的 5 月 29 日，英國的 Royal Abert Hall 也演唱了這首曲子，因此是一首值得提起的曲子。在 2:04 的地方可以聽到 Roger Waters 用型號 Sovereign H 1260 的空心吉他彈出優美的旋律，Nick Mason 做了相當大的幫助，他做了 POP 運用 Snare 及 Cymble 開場，Syd Barrett 表現出他所擅長的寬音域，而 Roger Waters 的 bass 聽起來變化多端，我們可以在 1:31 秒處聽到他的獨奏。這首曲子由 Joe Boyd 在 1 月 29 日到 2 月 1 日確認將錄製成唱片，他們花了一整天的時間錄製，接著第二天作混音。

Joe Boyd 說到：我記得在混音的過程 Roger Waters 和我都感到非常的棘手，這首曲子展現了 Syd Barrett 的作曲功力和音樂上的要求及特別的才華，以及同年推出的單曲〈See Emily Play〉。

### SEE EMILY PLAY

**Musicians**

Syd Barrett: vocal, rhythm guitar, lead guitar

Roger Waters: bass, backing vocals

Richard Wright: keyboard

Nick Mason: drum

[Lyrics]

Emily tries but misunderstands (ah ooh)

She's often inclined to borrow somebody's dreams 'til tomorrow

[Chorus]

There is no other day

Let's try it another way

You'll lose your mind and play

Free games for May

See Emily play

[Verse 2]

Soon after dark, Emily cries (ah ooh)

Gazing through trees in sorrow, hardly a sound 'til tomorrow

[Chorus]

There is no other day

Let's try it another way

You'll lose your mind and play

Free games for May

See Emily play

搖滾哲思

[Verse 3]

Put on a gown that touches the ground (ah ooh)

Float on a river forever and ever, Emily (Emily)

[Chorus]

There is no other day

Let's try it another way

You'll lose your mind and play

Free games for May

See Emily play

1967 的 5 月 12 日 Pink Floyd 在 Queen Elizabeth Hall in London（倫敦依麗莎白皇后廳），配合當時的聲、光、效果演出這首〈See Emily Play〉。英國在每年的五月都會舉辦場音樂會叫做「Games for May」，當 Pink Floyd 演奏這首曲子時由 Peter Jamer 和 Andrew King 共同操作影片投射，並與古典管弦樂團 Promoter Christopher Hunt 一起演出，可謂備受尊榮。英國的「Game for May」音樂會讓 Pink Floyd 奠定了在英國的知名度，因為他們創下了在演唱會上配合影像投射的創舉。

Nick Mason 說道：Syd Barrett 在寫〈See Emily Play〉這首曲子時，Andraw King 當時把房子分給 Syd 和 Richard Wright 同住，給他們很大的創作空間，而 Emily 這個名字被大家所關注，大

家不禁詢問：「誰是 Emily？」

　　她可能是在描寫一位著名的雕塑家，名叫 Emily Tacita Young[3]，她經常出現在 1966 年的 UFO Club，她總是偷取別人的夢想來創作，而這個女人在這首曲子裡總是出現在一個樹林裡；Syd 最喜歡的名字也正好就是 Emily，他曾說過，若自己有女兒的話，他要把她取名為 Emily。

　　但對 Roger Waters 來說 Emily 可能是任何人，她可能是個隨便就可以搭訕的女子、無知、無趣的女子。Roger Waters 說 Syd 寫這樣的曲子在樹林裡穿梭的女子，而我們大家就要像小朋友一樣在樹林裡玩捉迷藏，真是幼稚之極；而這個樹林也其實是存在於真實世界中的，即位在南劍橋的 Gog Magog Hill。

　　尚在此時，1967 年期間都還是由 Syd 擔任吉他手及作詞、作曲，作品充滿色彩、光影、美學觀點的描述，這個部分對於後來 Roger 的創作影響頗深。

　　1967 年 Syd Barrett（吉他手）、Roger Waters（貝斯手）、Richard Wright（鍵盤手）、Nick Mason（鼓手）共同分享這個搖滾舞台，將團名取為 Pink Floyd，名稱來自兩位他們崇敬的藍調歌手名字其第一個字：PINK Anderson 和 FLOYD Council。

　　Pink Floyd 的第二張專輯《Straight to Heaven》在 1967 年發

---

[3]　Emily Tacita Young 石雕家，1951 年出生，生長於藝術氛圍的家庭，父母皆為作家，並曾享有「英國最偉大石雕家」之稱。

行，而〈See Emily Play〉在英國當時 6 月 29 日於排行榜登上第六名的佳績，他們還有一首曲子叫〈Summer of Love〉就像當時的 The Beatles〈All You Need is Love〉一樣著名，或是像美國的 Scott Mckenzies 所唱的〈San Francisco Be Sure to Wear Some Flower in Your Hair〉。

See Emily Play 讓他們得到了在電視演出的機會，以及收音機廣播率最高的曲子之一，不只在倫敦的廣播播出，連美國的廣播也頻頻播出，1967 年 7 月 6 日，Pink Floyd 甚至被邀請到 BBC 演出。

《The Piper at the Gates of Dawn》是 Pink Floyd 的第一張專輯，專輯裡除了〈See Emily Play〉、〈Scarecrow〉和〈Bike〉等曲子，其餘都是在著名的錄音室－Abby Road 錄製而成，這些曲子就像長生不老一般，不斷地流傳著。〈Arnold Layne〉這首曲子由 Norman Smith 製作，當回到錄音室錄製時，他們的這首曲子回到了長版形式。別忘了 Pink Floyd 一向擅長製作超長版的曲子，Richard 總是彈著他的 Farfisa 型號的管風琴；Roger Waters 在這首曲子使用的是 Ricken Backer Bass 4001 bass。

Syd Barrett 注重的是節奏，而 Roger Waters 注重的是回音效果及迷幻感，這是他們在作曲上不合諧之處。

1968 年的演唱會，Syd Barrett 在台上脫序演出，隨後離團，Dave Manson 找了以前在藝術學院的同學，即當時於法國擔任模特兒的 David Gilmour，來擔任吉他手的位置。David

Gilmour 神乎其技的吉他功力使得整個樂團的表現更上一層。

　　當 Syd 因為嗑藥、酗酒而無法正常演出的事件發生後，讓 David Gilmour 第一次參與了 Pink Floyd 樂團的演出；1968 年發表的《*A Saucerful of Secrets*》使得他們脫離了地下樂團的範疇。

　　雖然只有四位團員，但他們的能力遠遠地超出了這樣的組織。創作的作品，有如大型劇院般，角色多樣，全世界獨一無二。Roger Waters 擅長營造的特效，為他們的音樂增添逼真的戲劇效果。古典與現代的搏鬥，在他們的作品中找到了溝通的契機，在「聲音、光影、詩」的開創下，大鳴大放，Pink Floyd 有如催眠師一般的魔力，將聽者帶往充滿想像的聲音之旅喚醒靈魂進入涅槃境地。如果說 Syd Barrett 以敏感的詩看待宛如奇妙的兒童視界，充滿童趣的系列，Roger Waters 則是以先知先覺的敏銳度來指導一齣齣警示警語的概念劇場搖滾（Arena Rock）。Pink Floyd 的作品以既寫實又偶而怪誕荒謬的表現形式洞悉人性深處，概念創作的主人翁總陷入某種困境，掙扎於真實又虛幻的情節，每一張作品都象徵人生各階段的人生隱喻。自 1971 年開始，他們的每一張作品，亦即由《*Meddle*》開始都以概念形式展現。並且在 1972 年間為由瑞士籍的導演 Barbet Schoerder 執導的電影 *La Vallée*（參與演出的演員：Bulle Ogier, Jean Pierre Kalfon and Michael Gothard，其中法國女演員 Bulle Ogier 也是 Barbet Schoerder 導演的妻子）配樂。從 1968 年起，David Gilmour 和 Roger Waters 對音樂的功力及技術

使得 Pink Floyd 最原始初衷「light, sound, poetry」的融合理念更
加成熟也更具魅力。

# The Meaning of Psychedelic Rock

## Chapter 02

## ──音樂是為了被感受，而非只是被聆賞

　　當 60 年代 Pink Floyd 成功創造了迷幻的前衛搖滾後，即確立了一種要求樂迷與樂手共同處於迷幻經驗中的聆聽經驗，60 年代 LSD、ACID 呈現出的迷幻效果其樂手仍處於在理性意識上的幻覺，只是將潛意識的部分凸起，因此樂手只要服用適量其意識與潛意識是能取得平衡的，這與現今的古柯鹼、海洛英、搖頭丸等具理智破壞，超 high 的誇張行為追求，以及失態的洩欲行為的狀態是大異其趣的。於最早成團時期，Clive Metcalf 是貝斯手，Roger Waters 是吉他手，Richard Wright 負責

節奏吉他，當時樂風以藍調為主，團名則改為 Abdabs。

　　Roger Waters、Nick Mason、Richard Wright 他們三人決定組成樂團，由 Mike Leonard 買下他們三人，他們當時只做 Live Show，以及在 Stan Hope Gardens 做些演出，Nick Mason 寫到「當時有一段時間我們用 Leonard's Lodgers 為團名」。

　　Syd Barrett 當時在 Camberwell School of Art 藝術學院上畫畫課，原本住在 Nick Mason 的家，但是 Syd 因為經濟狀況不佳、搬回去跟父母同住，當 Roger 知道 Syd 高中時唸的是繪畫藝術，Roger 便一直都想要邀請 Syd 入團。

　　因此當 Syd 來到倫敦時，Roger 便邀請 Syd 到 Adbabs，起初演出的是藍調曲風，加上 Syd 學的是藝術，所以他們的音樂，開始有了聲光影詩的結構，是一個古典 R&B 的樂團，但 Syd 說他並不喜歡 R&B，他比較喜歡爵士，或吉他與鍵盤上的即興演奏，此時 Roger 開始以貝斯手的身分出現，兩個月後 1964 年 12 月及 1965 年他們開始錄製母帶，第一張作品封面寫著「I'm a King Bee」，裡面有 Syd Barrett 做的三首曲子〈Butterfly〉，〈Lucy Leave〉和〈Remember Me〉。他們當時在一個叫做 Beat City 的俱樂部演出，還有在 Ready Steady Go！的電視節目演出，他們成功發行的第一張專輯《*The Piper of the Gates of Dawn*》

　　在 Syd Barrett 出狀況而又還沒找到吉他手之際，Pink Floyd 在 1976 年 11 月 14 到 12 月 5 號在巴黎的演唱會，他們找來了 Jimmy Hendrix 吉米漢著克斯同台演出，解決了這個棘手的問

題，當時 Syd 仍具有寫作的功能如《*Apples and Oranges*》（南轅北轍）以及《*Paint Box*》兩張專輯，但 Roger Waters 不准 Syd 再次上台演出，怕他脫序的演出會嚇壞觀眾也毀了團譽，在他們尋找吉他手的過程，Jeff Beck 也是其中一位令他們心動的吉他手，但最後由 Nick Mason 邀請了 David Gilmour 的加入，讓整個團抵定。在 David Gilmour 正式加入後他們發行了這四個團員陣容的第二張專輯《*A Saucerful of Secret*》，這張專輯的曲風與 Syd 在團時的風格大異其趣，也是 Syd 世紀的結束。這張專輯開始了 Pink Floyd 前衛迷幻搖滾的作風，因 David Gilmour 的加入，吉他多了許多實驗性的色彩。但很弔詭的是 David Gilmour 之前待的樂團演奏的是藍調曲風（Blues）但自加入了 Pink Floyd 這個樂團之後，深受 Roger Waters 的影響，因此《*A Sacucerful of Secrets*》便成了充滿實驗性的前衛搖滾專輯。

他們的經紀人 Norman Smith 在 David Gilmour 加入後宣稱這個團應由 David 來領導，但經由 Nick Manson 溝通協調之後，Norman Smith 很明顯地在溝通上輸給了 Roger Waters，Roger 堅持這個團的風格不能再像 Syd 在位時的風格，這樣的堅持讓他們這個團聲名大噪甚至影響了半個世紀的樂壇，之後出的專輯如《*Atom Heart Mother*》、《*Meddle*》及《*The Dark Side of the Moon*》（讓他們一舉成名的漂亮鉅作）。David Gilmour 的吉他彈奏法在這三張專輯裡是很難被模仿的 inimitable voice and dazzling guitar （無法被仿效的及暈眩感的吉他技法）Pink Floyd

的第二張專輯發行於 1968 年的 6 月 28、29 日，很快的攀升到英國排行榜的第 9 名。

Pink Floyd 的音樂很難讓人聽得懂，連英國方面的樂評家 Barry Miles 都很難聽懂而給與這樣的評語：「他們的音樂又長又無聊。」

這是一般無法理解他們音樂的人所給的共同評語，聽到這樣的評語我並不驚訝，因為聽不懂的共通感的確是如此的，沒錯。

而一位前衛藝術家 Vladimir Ussachevsky 對於 Pink Floyd 的音樂則大大的讚賞他說：「Pink Floyd 的音樂非常有創意而且樂曲的結構扎實，是個難以多得的前衛搖滾樂團」

All Music 及音樂百科全書給⊠A Saucerful of Secrets⊠這張專輯 4 顆星的高評。而這張專輯的封面由在 Leicester 大學唸電影製作的 Storm Thorgerson 設計，他要求 Roger Waters 及 David Gilmour 給他製作封面的機會，這張作品呈現了空間感，Storm Thorgerson 強調封面企圖呈現此樂團的整合性及獨特性。

David Gilmour 在這張專輯裡使用了白色的 Telecaster 玫瑰木的長頸吉他彈奏，並在英國著名的 Abby Road 錄製，由 Da Lane Lea 於 5 月 8 日混音成功，他曾經與 EMI 的 Peter Brown、Ken Scott、The Beatles、David Bowie、The Rolling Stones、Elton John、Lou Reed 合作過。

EMI 唱片公司的 Da Lane Lea 在 129 Kingsway London WCZ

控制室錄製聲音技術，使用了 18 個輸入器、4 個輸出軌使用機型為 AG 440 錄製帶，他還幫 The Who、Jimmi Hendrix 錄製過作品。

彈奏時，Roger Waters 仍舊忠心於自己常用的 Ricken backer 4001，Nick Manson 則忠於他的 Premier Kit 加上兩個 bass drum，Richard Wright 則在這張專輯裡介紹了一種新的混音合成鍵盤，他把音調至 M-102 "Spinet" Organ Mellotron Mk2 （是種震動式的風管，音色可以自己調製）

### JULIA DREAM

Song by Roger Waters 2:37

——這首曲子為 Pink Floyd 創下了重要的里程碑

### Musicians

David Gilmour: vocal, acoustic guitar, electric lead guitar

Richard Wright: mellotron, organ, backing vocals

Roger Waters: bass backing vocals

Nick Mason: percussion

**Recorded** Abby Road Studio, London: 2/13, 3/25, 4/3 1968 Studio 2 and 3 room 25

**Technical Team**

Producer: Norman Smith

Sound englineers: Peter Bown, Ken Scott, Phill McDonal

Assistant Sound Engineers: John Smith, John Barrett

[Lyrics]

Sunlight bright upon my pillow

Lighter than an eiderdown

Will she let the weeping willow

Wind his branches round

Julia dream, dreamboat queen, queen of all my dreams

Every night I turn the light out

Waiting for the velvet bride

Will the scaly armadillo

Find me where I'm hiding

Julia dream, dreamboat queen, queen of all my dreams

Will the misty master break me

Will the key unlock my mind

Will the following footsteps catch me

Am I really dying

Julia dream, dreamboat queen, queen of all my dreams

富裕的年代，讓這些年輕人有能力去消費昂貴的毒藥，呈現的只是多餘精力的宣洩。同性質的事物的接觸往往因為在不同的時空而產生不同的作用。

　　60 年代的 LSD 創造了偉大的搖滾年代，這是個為世界立聲的催化劑，到了 21 世紀竟成為現實世界的逃兵者，Staurt Hall[4]英國文化的研究學家指出，1968 年在嬉皮文化中，藥物的使用並不代表恣意狂歡，自我滿足的浮濫生活方式，而是透過開啟的另類的經驗，來顛覆現有社會秩序，這些經驗並非以教育成就，地位金錢與權力為導向，嬉皮也視音樂為提高心靈層次的主要媒介。

　　在 Pink Floyd 出頭之前已經有許多地下樂團默默地進行扎根的工作如早期的 Quick Silver Messenger Service, Buffalo Springfield, Warlock, Butterfield Blues Band，以及之後的 Jefferson Airplane, Grateful Dead……而 Grateful Dead 更是親身體驗和多次的實驗之後而改良出一種更容易被接受的迷幻語法。

　　雖然 Greatful Dead 從沒有出過任何暢銷作品，但他們的重要性不在商業上的成就，而在於他們創造了一種無需在精準的

---

[4]　Stuart Hall 為當代英國文化研究重要代表人物之一，關於「文化」、「權力」、「媒體與意識型態」之間關係的研究，提出「文化必須從社會結構、文化霸權、支配、抗拒、鬥爭等的角度加以考察」。他提出許多在文化和權力關係上令人印象深刻的著作，根據 Stuart Hall 的說法：「文化」是理解遍及意義、認同和權力的努力為重點。

節拍上展現自發性的想像的心靈狀態，引發直覺式的快速思考而構築出潛意識的音樂空間。1969 年 11 月 7 日他們在英國發行了《Ummagumma》專輯。

這是他們比較重要的實驗樂的第四張專輯，兩張一套超長版的作品，這張作品包括現場演出版的〈Astronomy Domine〉、〈A Saucerful Secrets〉、〈Set the Controls for the Heart of the Sun〉。（太陽總是出現在 Roger Waters 的作品裡，我們會在後面的章節裡做哲學部分的探討）

〈Careful with the Axe Eugene〉曲中，出現了兩聲尖叫聲，Roger Waters 以第一聲尖叫聲表示主人翁尤金（Eugene）被一隻著魔的斧頭引領去砍了他的朋友背脊，而朋友因此發出慘烈的叫聲，第二聲尖叫則是砍了人後的尤金發現自己所犯下的滔天大罪而崩潰的叫喊。

Roger Waters 在這首曲子理現場時露齒而叫出尖銳的嗓音，這張專輯另一張是在錄音室錄製，這一張專即對 Pink Floyd 來說是一個極大挑戰，因為它賦予了每個人獨立演出的展現，而且他們的音樂是那麼的難以模仿或複製。這張作品的錄音工程師是 Petter Mew，他回想當時他與製作人 Norman Smith 出現在錄音室時，Petter Mew 問 Pink Floyd 你們想怎麼呈現你們的曲子及什麼樣的合作形式呢？

Pink Floyd 團員回答：「我們決定四個人分別主奏，各持四分之一的部分來完成這張作品」；可謂實驗意味非常強大。

1967 年的《*Ummagumma*》是 Pink Floyd 樂團一個很大的轉淚點，因為他們以後的作品幾乎都可從這一張專輯裡找到很多的元素，甚至找到 Roger Waters 最初的震動聲波的訴求及 Richard Wright 使用 Rexox A77 的鍵盤音色，David Gilmour 改用白色用原木製成的 Fender Stratocaster 吉他（因為 David 在 1968 美國的現場演唱丟了他的 Telecaster）。Roger 仍使用他的 Ricken backer 4001 Bass 他們使用了 Sound city L 100 和兩個 Hiwatt DR-103 擴大器，兩個比較之後 Roger 跟 David Gilmour 都認為使用 Hiwatt DR-103 的效果比較好用來製作《*Ummagumma*》的錄音工作。

## GRANTCHESTER MEADOWS

Song by Roger Waters - 7:26

### Musicians

Roger Waters: vocal, classical guitar, special effects

**Recorded**: Abby Road Studio, London, March 24- August 25, 28 June 3 1969

### Technical Team

Producer: Norman Smith

Sound engineer: Petter Mew

Assistant sound engineers: Neil Richmond, Alan Parsons

（Alan Parsons 從《*Ummagumma*》就已開始為他們錄音
直到《*The Dark Side of the Moon*》才聲名大噪）

## SEVERAL SPECIES OF SMALL FURRY ANIMAL GATHERED TOGETHER IN A CAVE AND GROOVING WITH A PICT

Song by Roger Waters - 5:00

**Musicians**

Roger Waters: voice, special effects

Ron Geesin: scottish voice

**Recorded**: Abby Road Studio, London, September23 - December 17 1968 March 18, June 23 1969 Studio 2, Studio 3, room 4

**Technical Team**

Producer: Norman Smith

Sound Engineers: Petter Mew, Phil Mc Konald, Chris BlairAssistant

Sound Engineers: Jeff Jarratt, Neil Richmond Anthony Mone

在 4:32 秒處錄音略為減慢始能聽到這句話「That was pretty avant-grade wasn't it?」在〈Several Species of Small Furry Animals Gathered Together in a Cave and Grooving with a Pict〉裡面有段高頻率的吼叫聲，他是一個很高很瘦吸著煙，喝著酒穿著一身黑色 T-shirt 與長褲的男人吼叫，他就是 Roger Waters，在曲子前四分之一的部分 Roger 創作了第一部分用著很難的蘇格蘭音唱出片段，創下了令人印象深刻的一幕。Ron Geesin 曾有一段時間是 Pink Floyd 的團員，當創作 1970 年的《Atom Heart Mother》作品時大家覺得 Roger Waters 的聲音比 Ron Geesin 更適合這張作品的繼續創作，這是一張著重於管弦樂團，並以 E 小調為主軸彈奏的曲子，這張作品是首創將迷幻搖滾與管玄樂結合的經典之作，就像 Jethrortull 及 Genesis 在曲中加入許多長笛，在鍵盤方面他們用了許多 Mellotron 及合成器，就像 The Nice, King Crimson, Yes 這些搖滾樂團用這樣的樂器來填滿樂句與樂句之間的空隙及融合（fusion）Pink Floyd 迷幻搖滾的結合給當時新一代的樂團學習的榜樣，如 Nice, Keith Emerson, Deep Purple 的 Jon Lord。

還有 Yes 的 Rick Wakeman 以及在流行與藝術間找到共同相容處的如 Procol Harums〈A White Shade of Pale〉這首曲子的靈感來自 J. S. Bach 巴哈的 F 大調以及 1969 年 Jethro Tull's 的〈Bsource〉曲子選自 1969 年的專輯《Stand up》以及巴哈的

〈Suit for Lute no.1 E Minor〉。在管弦樂方面，Pink Floyd 首度在這張專輯結合古典與迷幻搖滾（Classic & Psychedelic）難度可謂相當的高。

Barbet Schroeder 及 Michelangelo Antorioni 兩位著名的導演分別用了這張專輯的作品當電影配樂。1969 年 6 月 26 日 Pink Floyd 在 Royal Albert Hall in London 與 Royal Philharmonic Orchestra 合作。EMI 給了他們很大的支持繼《Ummagumma》後又有另一劇作，Roger Water, Richard Wright, David Gilmour, Nick Menson 都願意再繼續合作下去，在迷幻搖滾之間行走。1970 年發行的《Atom Heart Mother》在 1994 年從新發行了 CD 由四位團員共同創作。

**Musicians**

Roger Waters: bass, percussion, sound effects

David Gilmour: electric guitar, rhythm guitar

Richard Wright: keyboard, organ, piano mellotron（梅勒特朗是當時的一種電子錄音器，多數樂團都會使用它）

Nick Manson: perssicion, drum, sound effect

Ron Geesin: arrangements

John Alldis: conductor choir and bass

The Phillip Jones Brass Ensemble: three trumpet, three trombones

**Recorded** Abby Road Studio, London, March 2, 3, 4, 24, June 13-16-24, July 8, 13, 15, 17 1979 Studio 2 and room 4

**Technical Team**

Producer: Pink Floyd

Executive Producer: Norman Smith

Sound Engineers: Peter Brown Phill McDonald

Assistant Sound Engineers: Alan ParsonJohn Leckie, John Kurlander, Nick Webb

這張連串作品曲子全長 23:43 秒，曲目：

1. Father's Shout: 2:52

2. Breast Mily: 2:53-5:26

3. Mother Fore: 5:27-10:11

4. Funky Dung: 10:12-14:56

5. Mind Your Throats Please: 14:57-19:12

6. Remergence: 19:13-23:43

# The Influences of
# Roger Waters

# *Chapter 03*

## ──**Roger Waters 對其後搖滾樂團的影響**

　　靈魂的提升，所追求的超越肉體的限制而達到喚醒靈魂的
涅槃境界，搖滾體現的是社會脈動？

　　跟隨創作原型的路徑走來可以察覺歷史的脈絡，這趟搖滾
的饗宴，享受過 60、70 年代超炫的技巧宣誓後，要在今日的
音樂中完全將「技巧」摒除在外，而改嚐由日漸凝滯僵化「急
凍式的音樂型態」，真所謂由奢入儉難，經歷搖滾大廚們的
精心料理嚐過算是三生有幸！現今的創作只能以微波餐來論
之，雖方便了創作人，卻苦了用腦聽音樂的音樂人。這樣的作

品玩味的成分也就單薄了許多，那是個思想的年代，只可惜年輕一輩沒有經歷過「精準」乃是限制樂手們創作的牢籠，如 1968 年成立的前衛樂團 King Crimson 就是一個在創作上各自獨立的樂團 1969 年的《In the Court of the Crimson King》創作力之驚人，著名的作品〈Epitaph〉、〈I Talk to the Wind〉、〈The Court of the Crimson King〉展現了「非精準上」的精準、失真（distortion）、爆破音（the breaking point），迷幻搖滾無法單以歌詞意涵的力量見長，通常聽到的是呻吟悶哼（groans）。1968 年成立的 Led Zeppelin 其唱法介於 Psychedlic 及 Heavy Metal，重點是整體的功力而非任何單一的元素，類似一種宗教狂熱的型態音樂。

　　Pink Floyd 得作品其追求與失落都符合了 60 年代的英國青年追求成功但又頹廢，從他們筆下的哲思，看得出那時的青年，雖然上進卻又必須與年代妥協的無奈，當時的青壯年也許敗給了命運，卻贏得了許多的崇敬，那是一個妥協與夢想互相拉鋸的年代。Pink Floyd 扮演了一個使命者與參與者的角色。

　　Roger Waters 本身命運的參與，拯救了多數人的夢想靈魂，Roger Waters 的題材總懷抱著每一個時代的希望，他提供了進入天堂的天梯，樂曲的形式就如英國畫家布雷克（William Blake）十九世紀所繪的畫作「雅各之梯」[5]（Jacob's Dream），

---

[5]　聖經創世紀當中，記載雅各在前往哈蘭的途中，在夢中看見了天梯，象徵著耶穌所想要成就的，便是讓人與神能夠重新和好，人能再度恢復與神的

他提供的天梯是「旋轉的」，也許爬起來多了點暈眩，卻也增加了裊裊繞繞的感覺。

　　1971 年 Pink Floyd 的作品開始變得非常哲學那年 Adrian Maben 為他們做了一個很強的實驗性影片，Pink Floyd 在 Pompii（龐貝古城）表演了〈Echoes〉這首曲子。Mobens 以俯瞰式高角度的方式作拍攝全景，拍攝融入了整個古羅馬古城遺跡，他們在龐貝城中心架設了電纜揚聲器所有的裝置。當時的 Pink Floyd 也正開始著手製作《*The Dark Side of the Moon*》，Roger Water 盡情在音樂的國度活的如此豐富（lavishly）。

**ECHO**

Song by Roger Waters, Richard Wright, Nick Mason, David Gilmour

**Musicians**

David Gilmour: vocal, electric rhythm, lead guitar, effects

Roger Waters: bass, fuzz bass, effects

Richard Wright: vocals, piano, organ, fuzz organ, effect

Nick Mason: drums percussion, effects

---

關係。

**Recorded** Abby Road Studios, London March 7,11,12, 15, 19

1971 studio2 Air Studios, London: July（正確的日子不知道）

Sound engineers: Pete Bown (Abby Road, and Air), Rob Black

(morgan)

Assistant Sound Engineers: John Leekie (Abby Road Air)

〈Echoes〉所要表達的是「循環之理」：水、水蒸氣、江河海水，不段循環，永遠存在。

〈Echoes〉是由起初名為〈Son of Nothing〉改名為〈Return of the Son of Nothing〉最後由 Roger 改名為〈Echoes〉發行於 1972 年 11 月 15 日在這麼多冗長的曲子中〈Echoes〉是他們這種樂風的最後一首，他們從 1971 年的 3 月開始錄製。

Richard Wright 在錄音室（Abby Road）時，Roger Waters 突然問他可否願意將他的鋼琴彈奏透過 Leslie 型號麥克風錄製好？

Richard Wright 答應了，結果這首曲子應該是所有冗長曲子中的最佳作品。Richard Wright 說到：「這是 Pink Floyd 正是定型的曲子」，而 Nick Mason 則表示：「演唱的部分是這麼清晰，清新簡單」。（到哪個段落是他說的話？）

透過 Leslie 型號的麥克風，這種麥克風通常是拿來錄製口琴、管風琴，而加以擴大器成音，Roger Waters 的建議使這首 Vocal 及鍵盤的部分變得非常獨特，再配合 David Gilmour 渴望表現的吉他彈奏法，這首曲子集合了大家的才華及創意而成

了一手偉大的作品，2007 年 Mojo 雜誌訪問 Richard Wright 有關〈Echoes〉曲子時，Richard Wright 聲稱整首曲子的架構是由他創作的，功勞應歸他，但 Roger Waters 這樣說：「這首曲子早在 Syd Barrett 離團時他就有了原創的想法，」他比喻到，「就算信天翁要夾取一物件時，也不可能毫無情緒的亂夾，一定有他的目標物才會夾取。」

雜誌社的記者說道：「我們寧可聽到〈Echoes〉作品是來自於他們之間彼此的合作，而不是彼此憎恨下的作品。」

Richard Wright 表示：「這首曲子是描寫地球初創時的海底景象，人類有其生命的期限，海底蘊育了生命，Pink Floyd 用了迴音器的效果使整首曲子充滿了強大的生命力，他們探討這個宇宙是有創造者的嗎？」

人類無法像大海一樣生生不息，人類就像被詛咒了一般，Roger Waters 提到希臘神話中那因為驕傲而忘記父親的叮嚀，導致飛得太靠近太陽將身上羽毛的蠟而融化，以致墜入海底而死亡的伊卡魯斯[6]；此作品是一首對很多現實事物失望及感到無奈的曲子。

---

[6] 建築師兼發明家之子代達羅斯，因幫助國王米諾斯建築迷宮，國王怕迷宮的路線被暴露，因此將父子倆囚禁在迷宮深處。為了逃出，代達羅斯設計了以蠟結合鳥羽製成的飛行翼，代達羅斯告誡兒子：「飛的太低，蠟翼會因霧氣潮溼而使飛行速度受阻；飛的太高，則會因陽光的高熱而造成蠟翼融化。」伊卡洛斯感到飛行很輕快，驕傲起來，於是朝高空飛去，然而太陽強烈的陽光融化了蠟，羽翼完全散開，最後墜落在洋洋大海中。

〈Echoes〉談的是物質不滅定理，正如一根木頭在高溫空氣的互動下，燃燒變成二氧化碳和水的形式存在，表象消失了實則我們看不見的暗物質及多維空間一直存在，所謂的人、靈魂只是生命菁華存在的一種形式。

「Pink Floyd: Live At Pompeii」，迷幻搖滾的最後歡呼，這是一場沒有任何聽眾的現場演出，〈Echoes〉在影片中，Part 1 及 Part 2 以拍攝遠古龐貝城的場景古代刻石、雕像都納入影片中，作為元素，他們想呈現宇宙初創的景象以符號性的風暴、火山岩、熔漿展現，……曲目包括了〈A Saucerful of Secret: Something Else, Syncopated Pandemonium, Storm Signal and Celestial Voice〉，〈One of These Days〉由《Meddle》這張專輯做開場，Nick Mason 說他們創作的曲子聲音就像是來自墓園一般。總而言之「Live at Pompeii」是搖滾史上的創舉及唯一，一場沒有觀眾的現場演出並拍成了影片，在 45 年後，2016 年的訪談，David Gilmour 談到他感到當時自己猶如是龐貝城的居民一般，感到非常的光榮參與演出，是一場非常值得的回憶錄。

**IF**

Song by Roger Waters - 4:30

**Musicians**

Roger Waters: vocals, bass accustic guitar

David Gilmour: electric guitar

Richard Wright: moog（一種管風琴）, organ, piano

**Recorded**: Abby Road Studio London: June 12, 25, July 4, 5, 8, 13 and 21 1970 (studio 2 and room 4)

**Technical Team**

Producer: Pink Floyd

Executive Producer: Norman Smith

Producer: Norman Smith

Sound engineer: Peter Bown

Assistant Sound Engineers: Alan Parsons, Nick Webb

[Lyrics]

If I were a swan, I'd be gone

If I were a good man, I talk to you more often than I do

If I were afraid I could hide

If I go insane, Please don't put your wire in my brain

　　所有的詞指向他在尋求一個精神上的庇護所，從〈If〉此張作品開始，他的作品指向精神哲學層次；Syd Barrett 的精神異常脫序演出對 Roger Waters 造成很大的後遺症，畢竟他

們曾經是那麼要好的朋友，在《The Dark Side of the Moon》作品中有一首叫〈Brain Damage〉，以及《Wish You Were Here》專輯中的〈Shine on Your Crazy Diamond〉再再都提到了 Syd 對 Roger Waters 的影響有多深，從他的許多個人作品中我們慢慢漸漸的會發覺他是一個在情感上多麼敏銳的音樂人，Marianne Faithfull 演唱了一首 Roger Waters 書寫 Syd 精神脫序的曲子以及他與 Syd 的友誼關係讓他非常心痛，但這首曲子並沒有收錄在 Pink Floyd 的任何一張專輯裡，此作品取名為〈Incarceration of a Flower Child〉，1968 年的作品直到 1999 年 Marianne Faithfull 則收錄到專輯《Vagabond Ways》。

Roger Waters 從〈If〉開始演唱功力驚人，他有著輕而有力的嗓音他的演唱才華非常能與他的情緒合而為一，而且也是一位非常精湛的貝斯手，善用它的 Fender 在 1:12 秒處他們用了新的樂器，錄製於 6 月 5 日，使用 Moog 調出 Moog IIIP 的音色由 Richard Wright 彈奏，David 用的是他的〈Black Strat〉用手指奏出曲線型的聲響而且將吉他橫放做出 Slide（滑音）的效果，並做出 Fuzzy（毛毛）的聲效，David 則自己重複錄製，作出和諧的合音。

在 3:16 秒處 Richard Wright 做了相當棒的即興演出，有趣的是 3:50 秒時 Roger Waters 把錄音效果從 Stereo（立體聲）改成 Mono（單音軌）在歌曲結尾時 Roger 用他的詞及嗓音做了很完美的終結。〈IF〉這首曲子毫無疑問的是 Roger Waters 很棒

的作品之一，而且與之後的作品有一以貫之的作用。1972 年《*Obscured by Clouds*》是他們的第七張專輯。

先前提到的導演之一 Barbet Schoreder，是名伊朗出生的瑞士導演，他於 1972 年的電影 *La Vall é e*，採用這首長約 3:05 秒的曲子〈Obscured by Clouds〉作為影片第一場的配樂，影片呈現由空拍山林的狀態，展現在尋找峽谷，透過雲層忽忽渺渺尋覓。

這首曲子的音樂基於合成器及區現行的吉他泛音，像被催眠式的節奏（hypnotic beat），是一首由 A 小調為主旳的曲子，鍵盤的音色是由兩台 EMS VCS3 互相輝映組成前衛後而扎實的音效，這首曲子主要是由 Roger Waters, David Gilmour, Richard Wright 做成使用的是 Hammond M-102 和 Mellotron。Nick Mason 也創做了一大段打擊樂的部分，Nick 的鼓是環狀的，不只有一整組的基礎組建，還有許多的呈現，不同的鼓氣呈現不同的音色，Nick Mason 很高興能在開場時打到電子鼓 Bongoes，這種鼓到 1976 年才大為盛行，當時只有 Nick Mason 及 Moody Blues 的 Graeme Edge 使用這個 Ludwig Kit 鼓組 David Gilmour 在這首曲子做了緩拍的彈奏。

Roger Waters 在這首曲子主要做的是工程錄音的部分，專輯中其中一首〈Wot's...Un the Deal〉唱的是一位離家思家鄉愁的人當回到家鄉時已雙鬢白佬，對於歲月的流失他感到非常的

懊悔，「There is no wind left in his soul...」，多麼優美的辭意啊！

　　Barbet Schroeder's 拍得非常唯美，〈Wot's...Un the Deal〉配合情愛的畫面對年輕女性產生情愫，Pink Floyd 的音樂都有驚人及醒目及暗示隱攝含義如〈A Saucerful of Secrets〉、〈Echoes〉、〈Set the Controls for the Heart of the Sun〉、〈Wot's... Un the Deal〉，David Gilmour 重複錄製分別彈奏兩次木吉他錄製第一軌及第二軌，Nick Mason 打著他的小鼓全曲充滿了莊園的清新感。

*Roger Waters'*
*Philosophy of Rock*

*Chapter 04*

## ──Pink Floyd 不只是迷幻那麼簡單的事了

2017 年 8 月 8 日在費城 Wells Fargo Arena 的演唱會一開場的
爆破巨響心臟的跳動聲女子的喊叫震懾全場，Roger Waters 以
這張專輯揭開序幕，《*The Dark Side of the Moon*》音效工程播放
那著名的詭異笑聲一開場就帶領所有的樂迷進入內心深層的壓
力，「breath breathin the air, don't be afraid to care...」搭配著他的
空心吉他開場，在黑色冥王星的爆發力下讓 Roger Waters 的表
演多了許多綻放想法，在他安靜的外表下，有著天馬行空的
思緒，猶如冥王星自身獨特的步調，兀自演繹出自己的行星軌

道。Roger Waters 對於細節的講究，努力達成完美的境界，用不同的星語訴說著「搖滾、古典、當代與解構」這幾個主軸。我們挑出這部作品具有另類意涵的曲子來理解他的哲思〈Brain Damage〉最末兩段的歌詞「and if the band you're in starts playing different tunes」意味著講述 Syd Barrett 因服用藥物過量以致脫序演出。

1973 年的《The Dark Side of the Moon》使 Pink Floyd 成為史上最偉大的樂團，這張從推出後就在美國 Billboard 排行榜駐紮直到 1987 年，總共打進 741 週近幾年來還沒有人打破這樣的紀錄。

Pink Floyd 的音樂從 Roger Waters 開始已經不是只是迷幻那麼簡單的事了。自從 Syd Barrett 離去後 Roger Waters 帶領 Pink Floyd 推出 1969《Atom Heart Mother》這部作品，確定了這個樂團從此偉大。最偉大的原因是 Roger Waters 在整體構思上的哲學概念性的把握！Roger Waters 搖滾名言錄：「不論你活多久飛多高，你在人生中所經歷的笑或淚都是彌足珍貴的個人人生經驗。」

自 Syd Barret 離開 Pink Floyd 後，1970 年代開始，Roger 的歌詞愈加的傾向悲觀與厭世的趨勢，在討論到 1973 年的專輯《The Dark Side of the Moon》中，Roger 坦言，這整張專輯皆是在討論政治與哲學，他說道：「對於整張專輯，是針對人們對於

投入金錢的追求，與其所造成的壓力、時光的飛逝，以及對權力結構，如：政治與宗教、暴力及侵略等等，造成人類與正面行為愈之疏遠的因素來做省思」。Roger 認為政治，與真實社會，及心理疾病，這些多重的壓力是造成與社會疏遠且難以克服的肇因，也因為這些主題，使 Roger 的詞如此的悲觀。從 Roger 的悲觀思想，可以衍伸看出其人生哲學與存在主義有所相似。存在主義屬於近代哲學的產物，存在主義的創始人，齊克果，因為反思上帝與人的關係，而發現黑格爾哲學並未真正回應人性中最真實的存在問題。

但反思與質疑上帝，並非存在主義的要旨，存在主義所關注的在於人本身存在意義。在齊克果之後，存在主義的哲學將還有尼采；馬丁布伯、薩特、卡繆等人。

在《*The Dark Side of the Moon*》中，〈Us and Them〉這首歌，與馬丁布伯在 1923 年的著作《我與你》（*I and Thou*）有著類似之處。「我與你」，在英文的原文 Thou 為古英文，在莎士比亞的劇作裡，是稱乎較親密的對象的用法。

馬丁布伯觀察著世界，發現這世界因為不斷物化的狀況，是一個對彼此越來越陌生的社會，可以說「最不陌生的事，便是『陌生』了」。社會為了達到高效率，加上現代工作的方式，精神的實在性都被物質所取代。馬丁布伯曾在這本著作裡寫道：「難道我們都沒有發現，在現代的工作方式，與占有的方式，已經幾乎把相遇人生與相遇關係的任何痕跡掃蕩無

存？」。

　　馬丁布伯也強調我與你的相識，不在於銷毀對方的主體性，也並非要融為一體，而是彼此承認皆有主觀層面，而不失客觀性，尊重對方的存在。依據他的觀點，人在世都會遇到衝突，因此隨時處於必須採取行動的狀態，需要不斷的對話。

　　布伯的「我和你」其中的對話準則，我和你，以及我和它，是著名的基本詞句，人在對話中的詞句不只是單一的詞組，而是我和你，以及我和它。布伯的對話準則，著重於我和你的人際關係，布伯認為，一個人無法透過「物體」的經驗進展到完整的自我，唯有經過和「另一個主體的人際關係」，才能使人，成為人。雖然如此，但這社會多半存在的關係卻是「我和它」，「它」代表著破碎與扭曲的人生，其中充斥著慾望，心機，時常因為要達目的而不擇手段，單靠「它」而生存的人，是不足為人的。我和你，我和它，兩者是相對立的，每個人〔我〕都需要另一個主體〔你〕（而非靠物質〔它〕）才能深切的認識真正的自我，以及擁有自我發展的機會。

　　而對於 Roger 的〈Us and Them〉，他自己曾表示，這首歌所談及的是「那些最為基本重要的問題，人類到底有沒有能力擁有人性？」。對於這些冷漠的人與人的互動，自私的政客；背後耍詐的奸商，我們開始築起高牆，是為了使「我們」（Us）與「他們」（Them）分化，換言之，在這樣的社會，

我們發現人與人之間是沒有連結性的。Roger 對於他所創作這首歌時的思想，他補充道「最終的問題是，我們是否有能力去處理與應付『我們與他們』的問題」。

Roger 的思想與另一位哲學家有相似之處的則是卡繆。法國哲學家，阿爾貝卡繆，是對於大西洋兩岸（英國及美國）二戰時出生的孩子影響力很廣的思想家。當 Roger 正在就讀高中時，英國哲學家柯林威爾遜（Colin Wilson）曾寫過一本帶有哲理性的著作《局外人》（The Outsider），深入的探討了當時的法國存在主義，以及其對於藝術的看法，讓當時的卡繆除了思想家的身分外，亦身為詩人與藝術家，他所創造的藝術作品並不是為了讓讀者或觀眾撫慰用的，更不是提供慰藉的依靠，反而是強化我們的苦難，表明且增強它。

然而為何苦難？這便是「存在」本身，存在便是苦難，Roger 與卡繆都對於存在抱持著同樣的看法，是為「荒誕」的。在每一個創作者或藝術家的作品中，都能找到其特色風格與痕跡，Roger 從他開始作詞時，詞中時常會有與卡繆相似的觀點，並且以同樣的形象來描述著「存在」，如：太陽、月亮、黑暗、石頭與牆。卡繆的薛西弗斯神話（Le Mythe de Sisyphe）描述著永不休止的荒謬性，薛西弗斯因為受到了懲罰，一生無窮無盡地推著巨石到達頂坡，隨後石頭又立即滾回了坡底。

每一個人都是薛西佛斯，唯一的差別在於自己是否認識到

這一點，如果某一天，「為什麼？」這一個問題浮現在腦中，厭倦了工廠式的生活，則開啟了意識的運動。荒謬，是卡繆著作的核心思想，美國文學家 William Faulkner 曾說對卡繆而言，生在這荒謬世界的人們，唯一真正的角色是對生活、反抗、與自由有所覺醒。

在《*The Dark Side of the Moon*》整張專輯當中，太陽等同於薛西佛斯裡頭的巨石。

例如〈Time〉其中的一段歌詞：

So you run and you run to catch up with the sun but it's sinking

Racing around to come up behind you again.

The sun is the same in a relative way but you're older,

Shorter of breath and one day closer to death.

不停追逐著太陽，然而太陽日落後，又從你身後升起；太陽依舊，但你卻逐漸老去，逐漸靠近死亡之日。

而〈Eclipse〉當中也提到過太陽，這裡的太陽，則較類似柏拉圖的「洞穴比喻」，柏拉圖要我們想像，在一個洞穴當中，有一群人他們的的身子被鐵鍊鍊著，他們世世代代都在這兒生活，因為脖子也被鐵鍊卡著，無法動彈也無法看見旁邊的人，更別說看見位於其身後的洞口，所有的囚犯都只能面向著

洞穴的內壁。洞穴裡的唯一的光線來源是一堆營火。在這營火與囚犯之間有一堵矮牆，

在遮蔽物的後面，有人拿著各式各樣的雕像走過，火光將這些雕像投射到了洞壁上，影子在內壁跳動著。這些被鐵鍊鍊住的人們，都以為眼前的這些影像是真實的事物，彷彿這些影子是真實的動植物，囚犯們已經習慣了這樣的生活，沒有掙脫鎖鏈的念頭，因為他們不為此感到悲慘。裡頭的人永遠無法看到真相，那些放在太陽底下的真相。

同樣的思想對應著 Roger 的歌詞：

All that you touch

And all that you see

All that you taste

All you feel

And all that you love

And all that you hate

All you distrust

All you save

And all that you give

And all that you deal

And all that you buy

Beg, borrow, or steal

And all you create

And all you destroy

And all that you do

And all that you say

And all that you eat

And everyone you meet

And all that you slight

And everyone you fight

And all that is now

And all that is gone

And all that's to come

And everything under the sun is in tune

But the sun is eclipsed by the moon

（There is no dark side in the moon really Matter of fact it's all dark）

——所有一切感官，知覺，所作所為，在太陽底下的真相被月亮遮蔽了。

**Musicians**

Roger Waters: bass VCS3

David Gilmour: vocals, voal harmonies electric rhythm and lead Guitar, EMS HI FI VCS3

Richard Wright: vocals, keyboards VCS3

Nick Mason: drums Rototoms

**Recorded**: Abby Road, Studio, London, June 8-10, 20, 22, October 17, 31, November 1972 january21, 24, 25 1973

**Technical Team**

Producer: Pink Floyd

Sound Engineers: Alan Parsons, Chris Thomas

Assistant Sound Engineer: Peter James

## Roger Waters 的黑色力量

Roger Waters 的演唱會一點都不浮誇，他不需要像其他的歌手頭戴羽毛像雄雞般吸引觀眾的注意力，他永遠穿著那套非常低調的黑T恤跟黑長褲，專業黑色的力量不受到外在的干擾。

黑色，忠實地回歸個性本質，傳達出滿載的力量以強勢的姿態內斂卻張力無限，當人的內在夠厚實時，真的不需要表象的東西來襯托自我，黑色基本上不是色彩，他可以被多色混合而成，但是無法是純黑否則眼睛是無法看見的，黑色的力量是倆倆對立的，可以是吞沒，也可以是包容，是虛無也是實在；是傷懷也是恆久的概念，Roger 充滿生命力的黑潮文化強力席捲全場，貫徹經典。叛逆迷情重溫復古與嬉鬧的恢意態度靈魂

與人性都需要解放。

　　所有的選擇都要發自內心的過癮，毫無將就，絕不妥協的覺悟，演唱會的現場如電影般大場景，在沙漠裡憑空拔起。就算是演唱會，他追求的是深邃心靈層面的創作，有詩有畫不是單向傳遞想法而是一場對話，近年網路有個流行語「燒腦」，顧名思義是燃燒腦細胞，意指要動腦筋才會懂的東西，60年代的音樂各個燒腦，沒想到50年後的今日竟然要這麼強調著這倆個字。

　　如果要找一部電影可以來更瞭解 Roger Waters 其人物與作品應該是克里斯多夫諾蘭的《敦克爾克大行動》，此戰役名列二次大戰十大關鍵戰役，描寫一九四〇年五月納粹歐戰無往不利時，四十萬英軍若不撤退返鄉，英倫三島將無兵豎防的作品。

　　兩者都具有超份量英國文化宣洩出來的創作力 Roger Waters 的作品一直有著如電影憂鬱的運鏡風格定調，歌詞更顯張力有著剛柔並存的語言。

　　舞台上的 Roger Waters 一深黑T恤（他的演唱會）像是裹著糖衣的誘惑，危險又不禁令人著迷每個片刻成就閃耀永恆，樂迷們無所畏懼的傾聽自己內心的聲音，宛如進入情感博物館。

　　當演奏〈Time〉時 2017 年的這幾場，鼓是由 Joy Walcol 擔任，全場屏住氣息在場的每個人高舉雙手，為 Roger Waters 撐

起一片蒼穹，等待他唱出「ticking a way the moments that make up a dull day」。

Roger Waters 要闡述的是，時光飛逝，而人生存的原因又在什麼地方呢？也許時間最終會告訴每個人生存的意義，但也許一切為時已晚，所以 Roger Waters 的偉大並不是對世界的批判和嘲諷，而是要每個人能清楚地揭示自我，他寫〈Time〉便是對人生最大的誠意。

我們在 Roger Waters 的作品中可以看見他的人生路途諸多悲慘的情節，不過所有的悲傷情節，無非是考驗一個人臨弱的本能，尤其要在尊嚴與沉落之間拿捏清楚著實不易。

〈Time〉看著時間的沙漏流逝，這就是生命，想不脫離生命的安排似乎不容易，如果我們以義大利哲學家喬瓦尼皮科[7]的看法來討論時間與人生的話，他認為正因為人擁有自由意志，所以人能做到任何事，也才能創造自身的命運。古希臘把宇宙視為大宇宙（macrocosmos）而把人類的身體看作小宇宙（microcosmos）彼此相對應，智者的精神是小宇宙，和大宇宙相對應，文藝復興是希臘思想的復甦，所以如何能在有限的生命時間裡將生命層次提升而品嚐各種滋味是 Roger Waters 的

---

[7] 喬瓦尼皮科‧德拉‧米蘭多拉（Giovanni Pico della Mirandola, 1463-1494）。我們創造的你，既非聖物又非凡人，既非永存，又非速朽。因此，你可盡按自己的意志，以自己的名義，創造自己，建設自己。我們僅僅讓你能夠按自己的自由意志成長與發展。你也許會蛻變成無理性的畜生；但是如果你願意，也可以開創神聖的生命。——《論人的尊嚴》

驅力。在 1983 年的《*The Final Cut*》中 Roger Waters 敲著真理之門，伴隨而來的無以數計的有關死亡、仇恨與戰爭的問題，而我們永遠也得不到答案，而那些即將上戰場的青年們，他們無從選擇自己的命運，他們只能做一抉擇，就是——「讓真理昏睡或是選擇死亡」。

## 夢境的歷練給了現實經驗

1968 年的《*A Saucerful of Secrect*》中有一首〈Julia Dream〉，這一首是出自 Syd Barrett 的筆下，寫在此書中是因為筆者認為這支作品影響 Roger Waters 蠻深的，因為談的是夢境的歷練給了現實經驗，我們可以在 1979 年的《*The Wall*》中看到故事的主人翁似乎陷於幼年時的夢境中無法自拔。

Roger Waters 總是能將負面的陰影轉化為非常強大的正能量的創作力，因此真正的幸福，往往不是來自於我們能擁有多少東西，而是在於我們擁有的東西能刺激多少的創造力，而創造力來自於想像，想像帶給人類的滿足，並不亞於現實。

**JULIA DREAM**

Song by Roger Waters 2:37

**Musicians**

Roger Waters: bass, backing vocals

David Gilmour: vocals, acoustic guitar, electric lead guitar

Richard Wright: Mellotron, organ, backing vocals

Nick Mason: Percussion

**Recorded**: Abby Road Studios, London, February 13, March 25
April 3 1968 Studios 2 and 3, room 25

**Technical Team**

Producer: Norman Smith

Sound engineers: Peter Bown, Ken Scout Phill McDonald

Assisstant Sound Engineer: John Smith, Hohn Barrett

[Lyrics]

Sunlight bright upon my pillow

Lighter than an eiderdown

Will she let the weeping willow Wind his branches round?

Julia dream, dreamboat queen,queen of all my dreams

Every night I turn the light out

Waiting for the velvet bride

Will the scalyarmadillo

Find me where I am hiding?

Julia dream, dreamboat queen, queen of allmy dream

Will the misty master break me?

Will the key unlock my mind?

Will the following footsteps catch me?

Am I really dying?

Julia dream, dreamboat queen, queen of all my dreams

Julia dream, dreamboat queen, queen of all my dreams

　　「人類為什麼會做夢」科學至今仍無法完全解釋夢的結構與樣貌。Sigmund Freud 西格蒙・佛洛伊德在《夢的解析》中提到「夢是現實生活中被壓抑願望的表現」在《The Wall》中，Roger Waters 筆下的小男孩在他的夢境裡似乎與現實相互的交錯著，他被壓抑的現實卻呈現在他的夢魘裡。夢是神祕而非現實的。

　　人在日常生活中不能滿足的慾望，或恐懼，會在夢裡無意識的產生精神作用，而導致影像化的形式。一般認為夜睡多夢是神經方面出了問題，其實不然，美國芝加哥大學心理學家 Clayderman 克萊德曼首先發現做夢不僅不會影響睡眠品質，也不會損害健康，而無夢的睡眠反而得不到睡眠的效果。

　　夢，是無意識界的想像，雖然是無意識，但被壓抑的希望並沒有消失，因此如能透過意識的想像來扭曲現實，當面對被扭曲的現實時，較能高於殘酷現實帶來的衝擊，因為「夢境的

歷練給了現實的經驗」。

這可以在 1979 年這張幾乎是 Roger Waters 的自述作品中窺見樣貌。

2017 年 7 月及 8 月的三場演唱會，一開場即是大幅的星空圖螢幕，在 Roger Waters 的太空中，凡事皆不可貌相，一聲巨響，揭開了序幕，看見金銀交錯的灰髮的 Roger 站在舞台的中央，彈著木吉他，唱著「breathe breathe in the air」，他以〈The Dark Side of the Moon〉作為開場，觀眾為之瘋狂地唱著，你可以看到在那個時空下，老、中、青三代的歌迷完全沒有代溝的界線。

Roger Waters 的悲劇人生造就了他的樂觀，「樂觀」是悲劇人生的原創，你的人生有多苦，你就有多樂觀，很多的小力量聚起來就是宇宙了！

Roger 他的旋律會強化意象，其善用音效的超然技藝使其轉變為意義重大的情感思想張力，他對政客的憤怒讓 Roger 的搖滾冠上了神聖之名。現代的音樂永遠無法為自己說話，就像「回聲仙女」，希臘神話裡的 ECHO，她註定永遠要呢喃他人話語的尾聲，卻永遠無法說出自己的內心對話及思想。我說過60、70 年代是用腦聽音樂的年代，現在重複的節奏、重複的電音、重複的詞句、重複的刷吉他、重複的連鼓，則是用屁股聽。搖滾反映的是社會的真實面，Roger 的痛是實存的，是感性的，社會性的。我們以倒敘的方式來探討 Roger Waters 的作

品，首先出場的是 1983 年 Pink Floyd 發行的《The Fiinal Cut》。

這張作品 David Gilmour 只參與了其中一首即〈Not Now John〉其他整張可說是 Roger 的個人專輯。Pink Floyd 也因為這部作品而彼此之間產生了嫌隙。但藝術是不能妥協的。Roger Waters 的作品之所以迷人乃在於他的「主觀」這也是創作者最幸福的事，能將內心最主觀的意識赤裸的呈現在作品裡，如果一件作品充滿了客觀的色彩，那恐怕什麼也不是了。

Roger Waters 在《The Final Cut》中很深的探討三個主題。這是一張最深入潛意識及意識的作品，是對他自己創傷的描繪，是描寫他父親 Eric Fletcher Waters 死於二次世界大戰時的意涵探討，是針對柴契爾夫人鐵腕政策的不諒解。

當我們聽到《The Final Cut》的〈The Gunners Dream〉時，其皮膚毛細孔感應到的溫度與濕度，是暗夜苦雨的吶喊，白髮人送黑髮人，一位母親參加了兒子因戰爭而捐軀的葬禮，故事的主人翁 Max 聽到母親對他說著「Good-bye Max」，逝者的靈魂，飄在空中回應著母親「Good-bye Ma」；並由 Raphael Ravencroft 吹奏的 Saxophone 串起了詞中描繪那老母的髮絲；Roger 唱出 Silver in her hair，細述著陽光照射在絲絲銀髮的老母頭上。第二段的 Saxophone 吹起牽腸掛肚的逝者的「夢想」hold on to the dream 這個夢想是希望能完成他爸爸為國犧牲的遺願，這世界不要再有戰爭了。人生在世最大的欣慰，莫過於知道深愛的親人，摯友都幸福快樂地活著。

**THE GUNNERS DREAM**

Song by Roger Waters 5:18

**Musicians**

David Gilmour: electric rhythm guitars

Roger Waters: vocals, bass

Nick Mason: drums

Ray Cooper: tambourine

Raphael Ravenscroft: tenor Saxphone

Michael Kamen: Piano, electric piano, orchestra conducting

Andy Bown: Piano, Electric piano

National Philharmonic Orchestra: Orchestra

**Recorded**

The Billiard Room ,London: May - October 1982

Hook End Recording Studios

Checkendon: June, October 1982

Mayfair Recording Studios, London: June, October,

November,1982 January 19, February 1983

Olympic Studio, London: June, October, November 1982

Abby Road Studio, London: July 22, 23 1982

Eel pie Studios, Twickehen: September 1982

RAK Studios, London: October 1982

Audio International Studios,London: January 26-30 1983

**Technical Team**

Producers: Roger Waters, James Guthrie, Michael Kamen

Sound Engineers: James Guthrie, Andy Jackson

Assistant Sound Engineers: Andy Cannelle, Mike Nocito, Jules
Bowen

[Lyrics]

Floating down through the clouds

Memories come rushing up to meet me now

In the space between the heavens

and in the corner of some foreign field

I had a dream

I had a dream

Good-bye Max

Good-bye Ma

After the serng slowly to the car

And the silver in her hair shines in the cold November air

You hear the tolling bell

And touch the silk in your lapel

And as the tear drops rise to meet the comfort of the band

You take her frail hand

And hold on to the dream

A place to stay

Oi! A real one

Enough to eat

Somewhere old heroes shuffle safely down the street

Where you can speak out loud

About your doubts and fears

And what's more no-one ever disappears

You never hear their standard issue kicking in your door

You can relax on both sides of the tracks

And maniacs don't blow holes in bandsmen by remote control

And everyone has recourse to the law

And no-one kills the children anymore

And no one kills the children anymore

Night after night

Going round and round my brain

His dream is driving me insane

In the corner of some foreign field

The gunner sleeps tonight

What's done is done

We cannot just write off his final scene

Take heed of his dream

Take heed

　　古羅馬斯多葛學派的哲學家 Cicero 西賽羅指出死亡或許會令人不安，但假如死後靈魂也隨之消失，那麼死亡就不足為懼了。反之死後若仍靈魂不滅，會到另一個世界去，如此死亡更應該是心之所願。Roger Waters 一點都不畏懼死亡，他只是覺得生命不應該葬送在戰場上，真的希望有輪迴，如有，那生命的蟲洞似乎已運作幾千幾萬年了。如果人們能記取歷史的教訓，鑑往知來，從歷史是可以看見未來，那麼這個生命的蟲洞人類也才不會再次把自己埋葬。

　　Roger Waters 期望在夢與死亡之間造一條路，為什麼我們總找不到答案，當我們敲門尋找時，總有上百萬個有關仇恨、戰爭、死亡的問題跟隨著。亡者的夢，就是希望恐懼不再跟隨，希望能有溫飽，沒有人會在因戰爭而消失，曲中提到 no one kills the children anymore，指的是英美兩國為了給予納粹德國的最後一擊。1945 年 2 月中旬，遭受四次轟炸的德國德樂斯登（Dresen）[8]，德軍俘擄了英國的許多空降部隊，曲子中的主

----

[8]　德國文化古城，於 1945 年 2 月 13 日至 15 日期間，遭遇四次空襲轟炸，2010 年德勒斯登發布的報告宣稱死亡人數為 22000~25000 人。

人翁跳下降落傘於德軍敵營的某處，知曉自己即將死亡，其一生在腦海裡快速閃過。

《The Final Cut》指的是故事主角人生的最後一幕，也有研究指出，其實 Roger 在寫這一張作品時，就已經有預感到 Pink Floyd 這個團即將解團，而他也不想再讓 Pink Floyd 往前進，因此將這張作品取名為 《The Final Cut》，但如果聽到標題曲時，另一個聲音又出現了，這個故事的主人翁因為受困於戰後的陰影痛苦不堪而想了結一生，同時又想尋求能自癒的方法。在歌詞中 Roger 輕輕地說出「teach」，自癒式的想教自己融入於這個社會，教自己如何躲藏笑，教自己如何躲藏哭泣，或是教自己像那些政客嗎？或乾脆讓自己發瘋吧！如何讓哀傷宣洩是個課題。

在〈The Hero's Return〉中甚至質疑上帝的存在，他問到──是禱告發生了什麼錯誤嗎？還是我們應該重新學習如何禱告？我必須再次強調 Roger Waters 的作品之珍貴乃在於真切地將自己受創的童年之陰影譜寫出來。Roger Waters 回憶兒時，他撇見了他的媽媽收到一封信，一片金葉子從信封裡滑落下來，那是一封捎來他爸爸死訊的信，來自喬治五世，寫著 Eric Flecture Waters 為國捐軀了。

這樣的兒時記憶使成長後的他變得憂鬱而自閉，我們從尼采的哲學觀來看 Roger 他是否也認為真實並不存在，「上帝已死」意指最高價值已然失去，長久以來人類奉為圭臬的真理其

實並不存在，這世界是無目的，無意義的。人生究竟是「為了什麼？」尤其是戰爭，這個問題欠缺答案。不過我們可以在 Roger Waters 的身上看到尼采的「超人」形象特質，他能夠承受現實之苦，維持堅強自我的人格，一張張作品的誕生就如尼采所謂的輪迴永恆，是肯定生命的極致，無以復加的極端化，它沒有開始，也沒有結束。

**THE HERO'S RETURN**

Song by Roger Waters 2:43

**Musicians**

David Gilmour: electric rhythm guitars

Roger Waters: vocals, bass

Nick Mason: drums

Ray Cooper: tambourine

Raphael Ravenscroft: tenor Saxphone

Michael Kamen: Piano, electric piano, orchestra conducting

Andy Bown:Piano, Electric piano

National Philharmonic Orchestra: Orchestra

**Recorded**

The Billiard Room, London: May - October 1982

Hook End Recording Studios

Checkendon: June, October 1982

Mayfair Recording Studios, London:June, October, November, 1982 - January 19, February 1983

Olympic Studio, London: June, October, November 1982

Abby Road Studio, London: July 22, 23 1982

Eel pie Studios,Twickehen: September 1982

RAK Studios, London: October 1982

Audio International Studios, London: January 26-30 1983

**Technical Team**

Producers: Roger Waters, James Guthrie, Michael Kamen

Sound Engineers: James Guthrie, Andy Jackson

Assistant Sound Engineers: Andy Cannelle, Mike Nocito, Jules Bowen

[Lyrics]

Jesus, Jesus, what's it all about?

Trying to clout these little ingrates into shape

When I was their age all the lights went out

There was no time to whine or mope about

And even now part of me flies over

Dresden at angels one five

Though they'll never fathom it begind my

Sarcasm desperate memories lie

Sweetheart sweetheart are you fast asleep? Good

Cause that's the only time that I can really speak to you

And there is something that I've locked away

A memory that is too painful

To withstand the light of day

When we came back from the war the banners and

Flags hung on everyone's door

We danced and we sang in the street and

The church bells rang

But burning in my heart

My memory smolders on

Of the gunners dying words on the intercom

　　每一張作品都代表著 Roger Waters 的再生，在〈Paranoid Eyes〉中，戰後的生還者回家了！但如何在這個社會生存呢？作品中隱喻式的探討生還者，將恐懼的靈魂藏躲於精神醫學上所謂的偏執狂的眼後，偽裝的戴上勇敢的面具，把自己假扮的輕鬆自如，彆扭的倚靠著酒吧檯，連露齒而笑都是那麼的僵硬，些微的笑聲都怕驚動了世界，生還者的靈魂已成碎片，到

處躲藏、隱身、藏匿，只為自己能找到一個不再生硬而能自癒的處所。Roger Waters 一直有著父親別去的恐懼，藏在眼內（paranoid eyes）……。

**PARANOID EYES**

Song by Roger Waters 3:40

**Musicians**

David Gilmour: electric rhythm guitars

Roger Waters: vocals, bass

Nick Mason: drums

Ray Cooper: tambourine

Raphael Ravenscroft: tenor Saxphone

Michael Kamen: Piano, electric piano, orchestra conducting

Andy Bown: Piano, Electric piano

National Philharmonic Orchestra: Orchestra

**Recorded**

The Billiard Room, London: May - October 1982

Hook End Recording Studios

Checkendon: June, October 1982

Mayfair Recording Studios, London: June, October, November,

1982 - January 19, February 1983

Olympic Studio, London: June, October, November 1982

Abby Road Studio, London: July 22, 23 1982

Eel pie Studios, Twickehen: September 1982

RAK Studios, London: October 1982

Audio International Studios, London: January 26-30 1983

**Technical Team**

Producers: Roger Waters, James Guthrie,Michael Kamen

Sound Engineers: James Guthrie, Andy Jackson

Assistant Sound Engineers: Andy Cannelle,Mike Nocito,Jules
Bowen

[Lyrics]

Dresden at angels one five

Though they'll never fathom it begind my

Sarcasm desperate memories lie

Sweetheart sweetheart are you fast asleep? Good

Cause that's the only time that I can really speak to you

And there is something that I've locked away

A memory that is too painful

To withstand the light of day

When we came back from the war the banners and

Flags hung on everyone's door

We danced and we sang in the street and

The church bells rang

But burning in my heart

My memory smolders on

Of the gunners dying words on the intercom

Button your lip. Don't let the shield slip.

Take a fresh grip on your bullet proof mask.

And if they try to break down your disguise with their questions

You can hide, hide, hide,

"I'll tell you what, I'll give you three blacks, and play you for five"

"Ta! You was unlucky there son"

"Time gentleman!"

Behind paranoid eyes.

You put on our brave face and slip over the road for a jar.

Fixing your grin as you casually lean on the bar,

Laughing too loud at the rest of the world

With the boys in the crowd

You hide, hide, hide,

Behind petrified eyes.

You believed in their stories of fame, fortune and glory.

Now you're lost in a haze of alcohol soft middle age

The pie in the sky turned out to be miles too high.

And you hide, hide, hide,

Behind brown and mild eyes.

　　Roger Waters 認為所謂的政客，能得到我們的任何尊敬嗎？他們可以把自己的勳章擦得耀眼奪目閃亮無比，又把笑容練得非常專業俐落，這些政客輕輕鬆鬆的 boom boom bang bang lie down your dead 就讓許多人橫屍遍野。

　　Roger Waters 的作曲功力及風格會與詞作最極端的呼應，巨大的音效聲響會先以最輕柔的嗓音展開然後轟然巨響放大到極致，如之前提到的 boom boom bang bang lie down your dead 整部作品是接續著情節而來，像似電影一般的敘述法。這張作品的製作人除了 Roger Waters 外還有 James Guvthin、Michael Kamen，另外還邀請到了 The National Philharmonic Orchestra 管玄樂團，讓《The Final Cut》更為壯觀。

　　這張專輯的第三部分提到的是 1982 年的福克蘭群島戰役，該年的 4 月到 6 月間英國和阿根廷為爭奪英方稱之為福克蘭群島的主權而爆發的一場局部戰爭，當時英國的執政者柴契爾首相曾與美國總統雷根進行調停的動作，而英國當時也分成反戰者與支持戰爭者兩派；福克蘭戰爭又稱馬爾維納斯

群島戰爭。

　　阿根廷於 1980 年代初期發生了經濟危機，和以加爾鐵里總統為首的大規模軍政府的運動，阿根廷政府試圖通過對福克蘭群島採取軍事行動，轉移視線，以解決國內的政治危機。英國反戰派認為應「歸還」馬島，如 1971 年讓島上居民領取阿根廷身分證，但之後這些反戰派反悔了，因為地質勘探報告顯示馬島南部海域下有儲藏著豐富的石油，而贊成戰爭這一派的一個英國議員稱：「我們寧可失去五個北愛爾蘭也不肯失去一個福克蘭群島」。

　　這個戰爭是這麼起來的，英國「征服者號」核潛艇發現阿根廷「貝爾格拉諾將軍號」於是徵詢柴契爾首相的意見，鐵娘子說：「打！！！擊沉它！」因此人類進入了「新海戰時代」。

　　2013 年福克蘭群島曾舉行了一項公投，島上的居民大家還是贊成「英屬」，雖然世界上對這一戰覺得英國人勝的憋屈。

　　Roger Waters 把柴契爾夫人比喻為希臘神話裡的那西瑟斯，自戀到淹死於自己的倒影裡；其中《The Final Cut》專輯中的第一首〈The Post War Dream〉唱出的 maggy maggy what have we done，指的即是這場歷史戰役，他認為這位鐵娘子見證了太多的殺伐了。

**THE POST WAR DREAM**

Song by Roger Waters 3:01

**Musicians**

David Gilmour: electric rhythm guitars

Roger Waters: vocals, bass

Nick Mason: drums

Ray Cooper: tambourine

Raphael Ravenscroft: tenor Saxphone

Michael Kamen: Piano, electric piano, orchestra conducting

Andy Bown: Piano, Electric piano

National Philharmonic Orchestra: Orchestra

**Recorded**

The Billiard Room, London: May - October 1982

Hook End Recording Studios

Checkendon: June, October 1982

Mayfair Recording Studios, London: June, October, November 1982, January 19, February 1983

Olympic Studio, London: June, October, November 1982

Abby Road Studio, London: July 22, 23 1982

Eel pie Studios, Twickehen: September 1982

搖滾哲思

RAK Studios, London: October 1982

Audio International Studios, London: January26-30 1983

**Technical Team**

Producers: Roger Waters, James Guthrie, Michael Kamen

Sound Engineers: James Guthrie, Andy Jackson

Assistant Sound Engineers: Andy Cannelle, Mike Nocito,Jules
Bowen

[Lyrics]

Through the fish-eyed lens of tear stained eyes

I can barely define the shape of this moment in time

And far from flying high in clear blue skies

I'm spiraling down to the hole in the ground where I hide

If you negotiate the minefield in the drive

And beat the dogs

tell me true tell me why was jesus crucified

is it for this that daddy died?

Was it for you?

Was it for me?

Did I watch too much t.v.?

Is that a hint of accusation in your eyes?

If it wasn't for the nips being so good at building ships

the yards would still be open on the clydeand

it can't be much fun for them beneath the rising sun

day with all their kids committing suicide

what have we done maggie what have we done

what have we done to England

should we shout should we scream

what happened to the post war dream?

Oh maggie maggie what have we done?

## 走出過往的蛻變

我們知道了 Fletcher 指的是 Roger 的父親，全名為 Erick Fletcher Waters；在〈The Final Cut〉的 MV 中，Roger 把自己的家設計成了悼念館，一心想為父親復仇。

第一句歌詞寫道 all your overgrown infants away somewhere，這些成長過速的嬰兒，腦子還沒發育成熟，就當了國家領導，在 2017 年的演唱會中他唱著 1977 年的作品《Animals》其中的幾首曲子，包括〈The Pigs on the Wing〉、〈Pigs (Three Different Ones)〉中反諷現在的美國總統川普之幼稚行徑（後續章節有更詳細解說）。讓我們回到 1983 年的作品，他指著那些領導人各個成了暴君（Tyrant）成了王。這些人每天藉由電視來宣

揚他們喪心病狂的理念，每個出現在歌詞中的人物都有代表的
意涵。

**THE FLETCHER MEMORIAL**

Song by Roger Waters 4:12

**Musicians**

David Gilmour: electric rhythm guitars

Roger Waters: vocals, bass

Nick Mason: drums

Ray Cooper: tambourine

Raphael Ravenscroft: tenor Saxphone

Michael Kamen: Piano, electric piano, orchestra conducting

Andy Bown: Piano, Electric piano

National Philharmonic Orchestra: Orchestra

**Recorded**

The Billiard Room, London: May - October 1982

Hook End Recording Studios

Checkendon: June, October 1982

Mayfair Recording Studios, London: June, October, November,

1982 January 19, February 1983

Olympic Studio, London: June, October, November 1982

Abby Road Studio, London: July 22, 23 1982

Eel pie Studios, Twickehen: September 1982

RAK Studios, London: October 1982

Audio International Studios,London: January26-30 1983

**Technical Team**

Producers: Roger Waters, James Guthrie, Michael Kamen

Sound Engineers:James Guthrie, Andy Jackson

Assistant Sound Engineers: Andy Cannelle, Mike Nocito, Jules
Bowen

[Lyrics]

Take all your overgrown infants away somewhere

And build them a home, a little place of their own.

The Fletcher Memorial

Home for incurable tyrants and kings.

And they can appear to themselves every day

On closed circuit T.V.

To make sure they're still real.

搖滾哲思

It's the only connection they feel.

"Ladies and gentlemen, please welcome, Reagan and Haig,

Mr. Begin and friend, Mrs. Thatcher, and Paisly,

"Hello Maggie!"

Mr. Brezhnev and party.

"Who's the bald chap?"

The ghost of McCarthy,

The memories of Nixon.

"Good-bye!"

And now, adding color, a group of anonymous latin-

American Meat packing glitterati.

Did they expect us to treat them with any respect?

They can polish their medals and sharpen their

Smiles, and amuse themselves playing games for awhile.

Boom boom, bang bang, lie down you're dead.

Safe in the permanent gaze of a cold glass eye

With their favorite toys

They'll be good girls and boys

In the Fletcher Memorial Home for colonial

Wasters of life and limb.

Is everyone in?

Are you having a nice time?

Now the final solution can be applied.

Mrs.Thatcher：指柴契爾夫人。

Reagan：代表美國政府，當時有和柴契爾首相調停著馬島事件，但最後為何還是宣戰了呢？這其中的機密無人知曉？

Mr Paisley：代表著英國的天空常出現的渦旋紋狀的雲一般稱為 Cloud Street 也常常被比喻為 Stairway to Heaven[9]

Nixon：代表著貪污和腐敗。

Latin American Meat Packing Glitterati：代表著一群無名的拉丁美洲裔的人被包裝得像上流社會的人，當時的選美節目常常由委內瑞拉小姐奪得后冠。

Mr Brezhnev：蘇維埃政府的布里茲涅夫。

這些人這些事在 Roger Waters 看來都是俗不可耐的，他們透過了大量的電視媒體來腐化你的心智。Roger Waters 似乎很痛恨電視這項產物，在《The Wall》的影片中可看見同樣的隱喻，一個行屍走肉的人總是坐在電視機前身體心裡都漸漸地腐蝕。

---

[9] Stairway To Heaven 是 Led Zeppelin 1971 年的作品，但被一支成立於 1967 的洛杉磯 Jazz Hard Rock 樂團指控此曲抄襲至 The Spirit 的舊作〈Taurus〉，Spirit 的 bass 手 Mark Andes 說，故事回溯在 1968 年 spirit 發行了他們的第一張同名專輯《Spirit》此曲〈Taurus〉是吉他手 Randy California 2 分37 秒。而 Led Zeppelin Stairway To Heaven 和他們的前奏有著太過神似的巧合。

創作型的人格多半不喜歡看電視，這是個值得探討的議題，為什們心靈層次高一點的人較不喜歡接近電視？Roger Waters 在這部作品中認為那些政客都像希特勒一般，都是無可救藥的暴君，那麼解決的方式就是 lets lock them away 把他們全都關到 The Fletcher Memorial Home 然後通通殺掉！在〈Your Possible Past〉，這個作品裡，看著那些被一車車載往戰地的士兵們，就像一車車被載往屠宰場的牛隻們，他要人們屏住氣息永遠記住這樣的情緒，詞中的 do you remember me？Me 指的是傷痛的情緒，How we used to be？Do you think we should be closer？Closer 指的就是緊緊相扣的情感連結。 Roger Waters 被自己的情感勒索著，而在這面英國國旗的背後，感到欲振乏力，一卡車一卡車的送去，而又一卡車一卡車的送回肢體殘缺的士兵及一卡車一卡車的屍體。

**YOUR POSSIBLE PASTS**

Song by Roger Waters 4:26

**Musicians**

David Gilmour: electric rhythm guitars

Roger Waters: vocals, bass

Nick Mason: drums

Ray Cooper: tambourine

Raphael Ravenscroft: tenor Saxphone

Michael Kamen: Piano, electric piano, orchestra conducting

Andy Bown: Piano, Electric piano

National Philharmonic Orchestra: Orchestra

**Recorded**

The Billiard Room, London: May - October 1982

Hook End Recording Studios Checkendon: June, October 1982

Mayfair Recording Studios, London: June, October, November, 1982 January 19, February 1983

Olympic Studio, London: June, October, November 1982

Abby Road Studio, London: July 22, 23 1982

Eel pie Studios, Twickehen: September 1982

RAK Studios, London: October 1982

Audio International Studios, London: January 26-30 1983

**Technical Team**

Producers: Roger Waters, James Guthrie, Michael Kamen

Sound Engineers: James Guthrie, Andy Jackson

Assistant Sound Engineers: Andy Cannelle, Mike Nocito, Jules Bowen

[Lyrics]

They flutter behind you your possible pasts

Some brightened and crazy some frightened and lost

A warning to anyone still in command

Of their possible future to take care

In derelict sidings the poppies entwine

With cattle trucks lying in wait for the next time

Do you remember me? how we used to be?

Do you think we should be closer?

She stood in the doorway the ghost of a smile

Haunting her face like a cheap hotel sign

Her cold eyes imploring the men in their macs

For the gold in their bags or the knives in their backs

Stepping uo boldly one put out his hand

He said, "I was just a child then now I'm only a man"

Do you remember me? how we used to be?

Do you think we should be closer?

By the cold and religious we were taken in hand

Shown how to feel good and told to feel bad

Tongue tied and terrified we learned how to pray

Now our feelings run deep and cold as the clay

And strung out behind us the banners and flags

Of our possible pasts lie in tatters and rags

Do you remember me? how we used to be?

Do you think we should be closer?

　　他憤怒政客的殘忍與戰爭的殘酷，Roger 被這樣的情感勒索著將其呈現在作品中，使搖滾再次偉大，當〈The Hero's Return〉時在 Roger 心裡沸騰的是那個 gunner （砲手）臨死前在對講機裡講的最後那一句話⋯⋯。

## Th Final Cut──人類不必為死亡而恐懼

　　對自己有強烈的自覺，年少時期的 Roger Waters，語調帶著憐愛與一絲惱怒，歌詞「Through the fish eyed lens of tear stained eyes」Roger Waters 從一滴眼淚看見如魚眼鏡頭下的型化社會，這讓我想到幾年以前，義大利（monza）莫札市議會禁止市民將魚養在圓形金魚缸裡，提案人指出這樣做很殘酷，因為當金魚凝視外面時，圓弧形的魚缸會讓金魚看到扭曲的事實。

　　Roger Waters 以魚眼鏡頭和一滴眼淚來讓我們省思這個社會難道真的是這個樣貌嗎？還是他早已被扭曲型化了？我們怎麼知道自己是位受扭曲的真實圖像呢？人類是否也住在一個巨大的金魚缸裡，透過一個巨大的透鏡而得到扭曲的視野呢？金魚對真實的圖像與我們不同，然而我們真的能夠確定牠們的世界觀比較不真實嗎？金魚的所見雖然與我們不同，但是他們仍

然可以提出一套科學法則，用以描述所觀察到魚缸外面的物體運動，我們觀察到一個物體以直線前進，但魚缸扭曲了視野，所以金魚會看到物體沿彎曲的路徑前進。雖然金魚的參考座標是扭曲的，但他永遠成立，雖然金魚的法則看起來比人類架構中的法則更複雜；今天 Roger Waters 提出這樣的理論，我們都必須深思對真實抱持不同圖像的觀察。Roger Waters 對自己有著太多的陰暗面，他害怕揭露自我，會不被這個扭曲的社會接受。他說「If I am in I will tell you what's behind the wall」，很明顯的這首作品原先是融於《The Wall》兩張一套的專輯裡的，但 Roger 有更龐大的構想，他創作了《The Final Cut》。

真的，**藝術是不能妥協的**，感恩他的不妥協。

### THE FINAL CUT

**Musicians**

David Gilmour: electric rhythm guitars

Roger Waters: vocals, bass

Nick Mason: drums

Ray Cooper: tambourine

Raphael Ravenscroft: tenor Saxphone

Michael Kamen: Piano, electric piano, orchestra conducting

Andy Bown: Piano, Electric piano

National Philharmonic Orchestra: Orchestra

## Recorded

The Billiard Room, London: May - October 1982

Hook End Recording Studios

Checkendon: June, October 1982

Mayfair Recording Studios, London: June, October, November 1982 January 19, February 1983

Olympic Studio, London: June, October, November 1982

Abby Road Studio, London: July 22, 23 1982

Eel pie Studios, Twickehen: September 1982

RAK Studios, London: October 1982

Audio International Studios, London: January 26-30 1983

## Technical Team

Producers: Roger Waters, James Guthrie, Michael Kamen

Sound Engineers: James Guthrie, Andy Jackson

Assistant Sound Engineers: Andy Cannelle, Mike Nocito, Jules Bowen

[Lyrics]

Through the fish-eyed lens of tear stained eyes

I can barely define the shape of this moment in time

And far from flying high in clear blue skies

I'm spiraling down to the hole in the ground where I hide

If you negotiate the minefield in the drive

And beat the dogs and cheat the cold electronic eyes

And if you make it past the shotgun in the hall

Dial the combination, open the priest hole

And if I'm in I'll tell you (what's behind the wall)

There's a kid who had a big hallucination

Making love to girls in magazines

He wonders if you're sleeping with your new found faith

Could anybody love him

Or is it just a crazy dream?

And if I show you my dark side

Will you still hold me tonight?

And if I open my heart to you

And show you my weak side

What would you do?

Would you sell your story to Rolling Stone?

Would you take the children away

And leave me alone?

And smile in reassurance

As you whisper down the phone?

Would you send me packing?
Or would you take me home?
Thought I oughta bare my naked feelings
Thought I oughta tear the curtain down
I held the blade in trembling hands
Prepared to make it but just then the phone rang
I never had the nerve to make the final cut

Roger Waters 今年 73 歲，斯多葛派哲學家西賽羅認為老年期是人生的高峰，這句話用在 Roger Waters 的身上再適切不過了。西賽羅說，人越老越能邁向哲學思想的領域，隨著年紀漸長，思慮會更趨成熟，有豐富的知識學養，看 Roger Waters 的辭藻彙而多汁，知識的淬煉、精神的殿堂，令所有的人望塵莫及。

專輯《*The Final Cut*》裡一再提到的，他不畏懼死亡，這與西賽羅的思想非常接近，西賽羅認為「接近死亡是一件非常美好的事。」他說人生有限度這件事是理所當然的，但這不是最重要的問題所在，重要的是人生是否過得充實？死亡或許會令人不安但假如死後靈魂也隨之消失，那麼死亡就不足為懼，不

用害怕接受審判，但這樣的無神論者會引起道德淪喪的危機，因此他又提出，死後若仍靈魂不滅，會到另一個世界去，如此，死亡更應該是心之所願，不必為死亡感到恐懼。

Roger 在〈Two Sun in the Sunset〉這首作品裡，把第二個太陽比喻為核彈，整個世界被戰爭所摧毀，曲子的後段有著氣象報告的解析：「明天的天氣多雲陰天，但氣溫會達到攝氏4000 度的溫度」，表示世界、人類、地球都將因核彈而毀滅。

Roger Waters 接受 Mojo 雜誌的訪問時說：「我們一直處於長期的意見分歧，我想 Pink Floyd 這個團到這張專輯為止，算是正式解散了」

# *The Wall*

# *Chapter 05*

## ──牆後真實

　　愛爾蘭作家王爾德：「我喜歡跟磚牆說話，那是世上不會反駁我的東西。」

　　《*The Wall*》幾乎是 Roger Waters 自傳式的描寫，其中〈Vera〉（bring the boys back home）指的是二次世界大戰時英國一個著名的女歌星 Veralynn 她唱的一首歌〈We'll Meet Again〉鼓勵青年們上戰場並保證所有的戰士我們會再碰面的，「Would ... Meeet Again ... Some Sunny Day」。

　　Roger Waters，他的爸爸再也沒回來，只能在暗中淌淚，

誰甘心歸去？Roger Waters 想到的是，這個世界到底要到什麼時候才會停止戰爭，除了諷刺 Vera 的謊言外，我們還必須了解 Roger Waters 的內在學問才能聽懂整部作品的脈絡，「Vera」在俄文裡指的是「Faith」忠誠度，除了指涉這位英國女歌手的謊言外，也指涉他的老婆對他的不忠；Roger Waters 常常感覺到自我不夠良好，以及他和另一半之間的關係常存在著「問題」，他無法赤裸裸地呈現自己於另一半的面前。甚至是宗教上的對話，他也無法確保「告解」，牧師就能了解他的苦。……太多的答案無法等待……

## VERA

[Lyrics]

Does anybody here remember Vera Lynn?

Remember how she said that

We would meet again some sunny day?

Vera, Vera

What has become of you

Does anybody else in here

Feel the way I do?

從 1979 年的作品的作品《The Wall》中可看出小時候的他

總是被欺負被霸凌，他快步地向前走，一直走到一個標誌寫著「死亡」的地方，他的童年總被一群騎著腳踏車的惡霸圍剿著，就像被一群鯊魚圍攻一般；Roger Waters 說道：「我總是孤獨一人，沒有朋友，走出房間對我來說是最危險的事。」原本令人擔憂的小男孩性格，以及最驚心膽跳的障礙在《The Wall》中找到了棲息地。因此 Roger 在有限的自由空間裡建築了他偉大的創作力。David Gilmour 說 Roger Waters 總會消失幾天去躲起來創作，他的作品都不是最主流的那種

## ANOTHER BRICK IN THE WALL (PART 1)

Song by Roger Waters 3:10

### Musicians

David Gilmour: electric rhythm and lead guitar, vocal harmonies

Richard Wright: Minimoog Prophet-5 Fender Rhodes

Roger Waters: vocals, vocal harmonies, bass

### Recorded

Britannia Row, I slington, London: September 1978 - March 1979

Super Bear Studios, Berre-Les-Alpes, Alpes-Maritimes (France) April-July 1979

Cherokee Recording Studios, Los Angeles: September 6-8 1979

**Technical Team**
Producers: Bob Ezrin, David Gilmour, Roger Waters
Co-Producer: James Guthrie, Nick Griffiths
Sound engineers: James Gurthrie, Nick Griffiths, Patrice Quet,
Brian Christian, Rick Hart

[Lyrics]
Daddy's flown across the ocean
Leaving just a memory
Snapshot in the family album
Daddy what else did you leave for me?
Daddy, what'd'ja leave behind for me?
All in all it was just a brick in the wall
All in all it was all just bricks in the wall

《*The Wall*》中的〈Another Brick in the Wall〉（Part 1）談的是人、是牆、是寒夜。「爸爸你飛過了海洋，你為我留下了什麼了嗎？」我只能在舊相冊裡看著父親的照片，盼望沒了⋯⋯父親的為國犧牲換來的只不過是他的名字被刻在牆上的另一塊磚，多麼的令人唏噓！

**COMFORTABLY NUMB**

Song by Roger Waters 6:24

**Musicians**

David Gilmour: electric rhythm and lead guitar, vocal harmonies

Richard Wright: Minimoog Prophet-5 Fender Rhode

Roger Waters: vocals, vocal harmonies, bass

**Recorded**

Britannia Row, I slington, London: September 1978 - March 1979

Super Bear Studios, Berre-Les-Alpes, Alpes-Maritimes (France) April-July 1979

Cherokee Recording Studios, Los Angeles: September 6-8 1979

**Technical Team**

Producers:Bob Ezrin, David Gilmour, Roger Waters

Co-Producer: James Guthrie, Nick Griffiths

Sound engineers: James Gurthrie, Nick Griffiths, Patrice Quet, Brian Christian, Rick Hart

[Lyrics]

[Verse1: Roger Waters]

Hello? Hello? Hello?

Is there anybody in there?

Just nod if you can hear me

Is there anyone at home?

Come on now

I hear you're feeling down

Well I can ease your pain

Get you on your feet again

Relax

I'll need some information first

Just the basic facts

Can you show me where it hurts?

（此處以 feedback 迴盪的效果運用，影響後來的團體創作甚鉅）

[Chorus1: David Gilmour]

There is no pain you are receding

A distant ship smoke on the horizon

You are only coming through in waves

Your lips move but I can't hear what you're saying

搖滾哲思

When I was a child I had a fever

My hands felt just like two balloons

Now I've got that feeling once again

I can't explain you would not understand

This is not how I am

I have become comfortably numb

[Verse2: Waters]

Okay (okay) (okay)

Just a little pinprick (ding)

There'll be no more,

ahhhhhhhhhh

But you may feel a little sick

Can you stand up?

I do believe it's working, good

That'll keep you going through the show

Come on it's time to go

[Chorus2: Gilmour]

There is no pain you are receding

A distant ship, smoke on the horizon

You are only coming through in waves

Your lips move but I can't hear what you're saying

When I was a child

I caught a fleeting glimpse

Out of the corner of my eye

I turned to look but it was gone

I cannot put my finger on it now

The child is grown

The dream is gone

I have become comfortably numb

　　〈Comfortably Numb〉揭示了一個悲劇的事實，是他澈底的被傷害過，感受他曾經歷過的失去，我想在這部作品未成熟前 Roger Waters 還不夠瞭解自己，也無法確定自己會成為什麼，或變成什麼？他從小敏感而孤獨，不僅別人無法靠近他，連他自己都無法擁抱自我。他肯定在某個時機點開始毀滅自己。歌詞說到：「just a little pin prick Ahhhhhh」這是個遍體鱗傷的生命，但生命一定會為自己找到生存下去的方式，Roger Waters 為自己的靈魂找到的就是擴大自己寂寞的生活圈，唯有孤獨是他存在的位置，外面的環境對他來說太詭譎，四周的眼光令他窒息，人類令他抓狂，Roger Waters 筆下的自我，把自己擺在一個非常自憐的高姿態，創傷在他的靈魂裡成了最大的創力，也是最美、最特別的創作，這是自我保護的機制；這個

世界對他來說太庸俗了。心理學家史匹德勒（Spitterler）對這樣的人格說：「來！讓我們與眾不同」，充滿恐懼的擔憂在成長的過程建構了他的大腦，完整的防衛機制他比一般受保護的孩童內斂。威勢而冷眼，「沒有朋友」是他們所自以為豪的優勢，當多數的青年認同於一般大眾文化之下，他不用同樣的方式尋求歸屬感，而是以較勁的姿態凌駕於同儕團體。

　　這樣的孩子，動腦多過於體力的運動，他們的情緒恆久處於動蕩的狀態，前一秒會覺得自己是曠世奇才，但下一秒又對自己的信心跌落深淵，也就有了〈Comfortbly Numb〉的誕生，談的是 Roger Waters 幼年時沒有建構完成的存在感，信任感，所欠缺的安全感，會在日後的人際關係上造成障礙，有些人在面對人際時表現得逆來順受著「社交不耐症」，他必須躲在自己的軀殼裡才能些許感到這個世界的溫度，他對這個世界沒什麼興趣，他的世界早就被恐懼淹沒了。對神，也早就不存在信仰。（在《The Final Cut》）1983 年的作品中的〈The Post War Dream〉中的第一段詞看到「tell me true, tell me why was jesus crucified is it for this that daddy died?」《The Final Cut》的作品其實是與《The Wall》相呼應的，本來是要把《The Final Cut》放在《The Wall》中的，但後來 Roger Waters 有了更偉大的想法，而製作了獨立的一張曠世鉅作。

## Roger Waters 的伊底帕斯情結

　　心理學上所謂的伊底帕斯情結（Oedipus Complex）指的是以本能衝動力為核心的一種慾望，通俗地講是指男性的一種心理傾向，是無論到什麼年紀，都總是服從和依戀母親，在心理上還沒有斷乳。所謂情節是指情感上的一種包袱，人稱 mommy boy。戀母情結源自古希臘羅馬神話的傳說，傳說底比斯國王來搖斯，受到阿波羅神諭的警告：「如果他讓剛出生的兒子長大，他的王位與生命就會發生危險」，於是他讓獵人把兒子帶走並殺死，但獵人動了惻隱之心，只將嬰兒丟棄，丟棄的嬰兒被一位農夫發現並送給其主人養大，多年以後，來搖斯去鄰國朝聖，在路上遇到一個青年並發生爭執，他被青年殺死，而這位青年竟然就是當年他丟棄的嬰兒伊底帕斯，另一方面，伊底帕斯破解了人面身獸斯芬克斯之謎，被底比斯人民舉為王，並娶了來搖斯的遺孀王后柔卡斯塔為妻。

　　後來，底比斯發生瘟疫和饑荒，人們請教了神諭，才知道伊底帕斯殺父娶母親的罪行，於是伊底帕斯終於明白，然後挖了雙眼，離開底比斯⋯⋯。戀母情結的本質是相似和互補的，以男孩為例，他與父親同性，所以相似，而相似引起認同，使男孩以父親為榜樣，向父親學習，模仿父親，把父親的心理特點和品質吸納進來，成為自己的心理特徵的一部分，男孩與母親不同性，兩性可以互補，取長截短，相依為命，這就成為對

象愛，於是與自己的父母形成了最基本的最初的人際關係，這種人際關係可以用戀母情結來概論之。

戀母情結關係中，常常伴隨著相互成長，父親愛母親，而男孩模仿父親，他就會越來越愛母親。戀母情結是成長期最基本的人際關係，長大以後的各種人際關係都不同程度地受戀母情結的影響，最初會在三到六歲時出現，此時男孩會開始學習並且模仿父親，與母親的關係會比和父親的關係更為親密，進入青春期之後，會出現尋找母親的代替者為感情對象，有時會從父母親的朋友或長者甚至是老師來作為崇拜的對象，其互補的作用就是愛上比自己年紀大上很多的異性，這樣的小孩通常會編造自己的身世，認為自己不是親身的父母所生養，認為自己是被領養的。

身世的幻想，他們會在英雄神話裡找到答案。

青春期的重要工作就是擺脫父母，為自己尋找父母的替代者，嚴重的話會導致毫無根據的認定自己不是現在的父母親所生。隨著年齡的成長，戀母情結的對象會漸漸年輕化，終於被同齡層的異性所取代，那是相對於自己年齡的成長，而父母的意象並沒有成長這樣的矛盾與衝突。

他們會漸漸地從交友或情感對象同齡化的趨向去尋求，戀母情的對象也就越來越年輕，但是此時往往會出現兩種狀況，一種是對抗，一種是合作，會自動把他人分為朋友或敵人，憎愛分明，美其名為忠誠度，其實是互補作用，還會把愛分成性

愛激情，及女神似的精神愛戀對象，也會把男人分為君子或色狼，隨著年紀的成長而能統合性與愛，但並不是每個人的成長階段都這麼順遂形成，有些人一輩子也無法完成統合……。

　　Roger Waters 的〈Mother〉這個作品裡有很深的剖析他戀母情結沒有完成統合的境況，根據心理學家佛洛伊德得分析，有戀母情結的男性在和妻子的關係上往往是非常的困難，假如妻子批評了自己的母親，就會產生罪惡感及厭惡感，他們缺乏勇氣與勇敢去對抗母親以致將自己的婚姻葬送在自己的戀母情節中……抑制自己的主張，貪戀母親的呵護，精神容易慢性萎縮，他們覺得接受母親的愛就等於愛母親了，這是一個單向思考的，他的內心不敢做出任何的決定，內心懷著對母性關愛的強烈依戀……一九〇五年佛洛伊德在「性學三篇論文」中強調，戀母情結對於個人日後關係影響極大，他強調每一個人不要排斥戀母或戀父的感情，如果我們只是壓抑，排斥，對於我們的兩性關係會有負面的影響，佛洛伊德認為，戀母情結或是戀父情結，是個人人格成長必經的階段，是無可排斥的事實，佛洛伊德主張我們每個人都應該承認這一項人格發展，而與之妥協化解糾纏……戀母情結是一種成長的學席過程往往在愛情中失衡，愛情是一種「取」「捨」但是如果發展不夠成熟的往往只想到前者。

　　Roger Waters 的成長過程媽媽扮演了天使與惡魔的雙重角色，他的戀母情結含著懼怕與期盼，可以從他的發問看出

了他對同性的懼怕：「mother do you think they'll try to break my balls?」歌詞中看出他想靠築起牆圍來保護自己，對於 Roger Waters 來說牆是一體兩面的物體，一方面她覺得既可保護他不受外界攻擊，只要是媽媽為他築起來的牆，她就給了他相當大的安全感，只要關在牆裡他都有信心能勇敢率性……，媽媽會把你保護在我的羽翼下，媽媽不會讓你飛出但會讓你唱，Roger Waters 似乎在筆下暗示著他的媽媽不只過分保護而且還有擁有惡魔般操控權的一面，因為歌詞中的母親說：「我也會把所有的恐懼也灌輸給你……」。對於女人他完全仰賴於媽媽的抉擇，他甚至有潔癖到不願去碰觸「性」這個區塊，媽媽的過度保護在作品中可聽到，他一方面非常無力去反抗，他連「牆」被蓋得過高也無法抗拒……因為媽媽說著「我會把你的惡夢讓你在牆內實現！」如果以電影的手法來呈現恐懼的話，希區考 1960 年上映的《驚魂記》（Psycho）講述一個精神分裂症的男人──Norman，因為他媽媽從小不讓他跟外界接觸，並且塑造自己完美崇高的形象，在這個男人心中，媽媽是完美的，所以之後把屍體留下來陪伴，也因為太愛媽媽了並憎恨所有的女性，他認為所有的女性都是骯髒不潔的，因此只要投宿於他開的旅社，他都將他們殺害，自己則假扮媽媽與他自己通電話，把媽媽乾扁的屍體放在窗邊的搖椅上，自己則裝的很孝順很乖巧地聽著媽媽的話，是的媽媽……好的媽媽……每天忙進忙出，其實只有他一人。

Should I build a wall?

Of course momma's gonna help you build a wall.

Mother gonna check out all your girlfriends for you,

mamma won't let anyone dirty get through....

mother did it need to be so high?

**MOTHER**

Song BY Roger Waters 5:32

**Musicians**

David Gilmour: electric rhythm and lead guitar, vocal harmonies

Richard Wright: Minimoog Prophet-5 Fender Rhode

Roger Waters: vocals, vocal harmonies, bass

**Recorded**

Britannia Row, I slington, London: September 1978 - March 1979

Super Bear Studios, Berre-Les-Alpes, Alpes-Maritimes (France) April-July 1979

Cherokee Recording Studios, Los Angeles: September 6-8 1979

搖滾哲思

**Technical Team**

Producers: Bob Ezrin, David Gilmour, Roger Waters

Co-Producer: James Guthrie, Nick Griffiths

Sound engineers: James Gurthrie, Nick Griffiths, Patrice Quet,
Brian Christian, Rick Hart

[Lyrics]

Mother, do you think they'll drop the bomb?

Mother, do you think they'll like this song?

Mother, do you think they'll try to break my balls?

Ooh, aah, mother, should I build the wall?

Mother, should I run for president?

Mother, should I trust the government?

Mother, will they put me in the firing line?

Ooh, aah, is it just a waste of time?

Hush now, baby, baby, don't you cry

Mama's gonna make all of your nightmares come true

Mama's gonna put all of her fears into you

Mama's gonna keep you right here under her wing

She won't let you fly but she might let you sing

Mama's gonna keep baby cozy and warm

Ooh, babe, ooh, babe, ooh, babe

Of course mama's gonna help build the wall

Mother, do you think she's good enough for me?

Mother, do you think she's dangerous to me?

Mother, will she tear your little boy apart?

Ooh, aah, mother, will she break my heart?

Hush now, baby, baby, don't you cry

Mama's gonna check out all your girlfriends for you

Mama won't let anyone dirty get through

Mama's gonna wait up 'til you get in

Mama will always find out where you've been

Mamma's gonna keep baby healthy and clean

Ooh, babe, ooh, babe, ooh, babe

You'll always be a baby to me

Mother, did it need to be so high?

搖滾哲思

# *United we stand, divided we fall*

# Chapter *06*

## ──孤獨的傷，自我靈魂演化

　　真正的安全感並不是一個外在的現象，而是一種內在的狀態，它來自於根於生命，與跟自己內在的聯繫，在古希臘神話中有一段著名軼事與泰勒佛斯（Telephos）[10]有關，泰勒佛斯被凱龍送給佩琉斯（Peleus）的矛所刺傷，當他發現這個傷怎麼也好不了時，只好請教阿波羅神諭，而他所得到的回答是「此傷惟有其源由才能醫治」。

---

[10] 在希臘神話當中，泰勒佛斯是大力士海克利斯與晨光女神奧格的兒子，曾被認為將會是泰格亞的國王，但最後卻治理了小亞細亞（安納托利亞）地區。

希臘神話中的凱龍的傷，成為能透過醫治自己而得以自癒的能力，出自他全部故事中的一個核心片段。這個故事有幾個不盡相同的版本流傳至今，其中一個講到：「某日海克利斯去到半人馬佛魯斯居住的洞穴拜訪，佛魯斯拗不過這位英雄客人的再三要求，打開了他那罈著名的美酒，然而外面那些野蠻半人馬們，一聞到酒香便開始躁動發狂了起來，於是在一陣而起的兵荒馬亂中，一支海克利斯發出的箭射在了凱龍的腿上，凱龍並不會死去，因他是一個半神（demigod 這是指擁有神一般的性質，而不是指他一半是神一半是人）；但他也找不出方法治癒這次的傷，這個傷勢就這樣伴隨著他，度過他漫長的餘生。不過如同我們將會見到的，他的苦處最終還是得到解決。

　　另外一個版本的故事則是說，有一隻受傷的半人馬掙扎爬進凱龍的洞裡尋求庇護，在試著伸出援手的時候，凱龍自己也不小心受毒箭所傷，而被永無止歇的劇痛所擊倒。請注意，凱龍之所以受傷並不是他的錯，另外，凱龍的傷是在他動物的那半身，這點強調了我們那動物性的身體，其存在有多脆弱，這個傷勢也可看作與此現象對應，凱龍的傷正代表了那些關於被壓抑的事物再度浮現，以及那些當我們遭遇自己內在的九頭蛇之毒時所感受到的痛苦。[11]這種好不了的傷，對 Roger Waters 來說，是反覆不停的出現，可能是重現在我們與異性別父母的早

---

[11]　部份摘自 Melanie Reinhart Chikon and the Healing Jouney

期關係，那些經驗足以使我們深深以為，任何關係都帶有危險，應該加以避免，似乎永遠無法獲得解決的模式，儘管他已經不停在尋找治療的可能，英雄部分的終止之處，就是他的開展之處。Roger Waters 的牆築得太高了，以致於他想求助於外界的人，也難以觸及，就像你的嘴喊不出聲音來，而外界也聽不到任何牆裡面的喊叫，沒有人知道牆內關著一個及待救助的人，到最後他被自己的傷口腐蝕，埋葬在自己所築起的牆裡。但是別忘了，這個牆是由他強勢的媽媽幫他蓋起來的！

　　高聳的牆，呼天喊地都無人知曉裡面有「他」。HEY YOU！是他試圖叫著任何一位路過的人，但是外面的世界也是一個冰冷的世界，牆裡牆外……日趨冷眼……他要外界的力量幫他破牆而出，但是，當牆垮的那一刻，也是他被埋葬的那刻。

**HEY YOU**

Song by Roger Waters 4:42

**Musicians**

David Gilmour: electric rhythm and lead guitar, vocal harmonies

Richard Wright: Minimoog Prophet-5 Fender Rhode

Roger Waters: vocals, vocal harmonies, bass

**Recorded**

Britannia Row, I slington, London: September 1978 - March 1979

Super Bear Studios, Berre-Les-Alpes, Alpes-Maritimes (France) April-July 1979

Cherokee Recording Studios, Los Angeles: September 6-8 1979

**Technical Team**

Producers: Bob Ezrin, David Gilmour, Roger Waters

Co-Producer: James Guthrie, Nick Griffiths

Sound engineers: James Gurthrie, Nick Griffiths, Patrice Quet, Brian Christian, Rick Hart

[Lyrics]

Hey you, out there in the cold

Getting lonely, getting old

Can you feel me?

Hey you, standing in the aisles

With itchy feet and fading smiles

Can you feel me?

Hey you, don't help them to bury the light

Don't give in without a fight

Hey you out there on your own

Sitting naked by the phone

Would you touch me?

Hey you with you ear against the wall

Waiting for someone to call out

Would you touch me?

Hey you, would you help me to carry the stone?

Open your heart, I'm coming home

But it was only fantasy

The wall was too high

As you can see

No matter how he tried

He could not break free

And the worms ate into his brain

Hey you, out there on the road

Always doing what you're told

Can you help me?

Hey you, out there beyond the wall

Breaking bottles in the hall

Can you help me?

Hey you, don' tell me there's no hope at all

Together we stand, divided we fall

　　人腦科學家研究指出人的腦部皺摺越多表示腦力的開發越發達，超凡入聖的人物 Roger，是佔據主要意識的中心，他認為世俗的一切令腦袋平版化，產生不了皺摺，他有不同的社會價值觀，他收藏腦部的皺摺，毫無將就，覺悟那絕不妥協。我聽著他的創作時，總是泛著淚的，就像聽維瓦爾第的四季一樣，淚水訴說著我是何等的幸福能聽到這樣偉大的創作，多少春秋風雨改，Roger Waters 成就了他自己的偉大，也成為專業的獨行者。

　　在錄音室錄製〈Comfortbly Numb〉時「there is no pain you are receding」這段由 David Gilmour 唱著（以退潮的方式暗喻故事主人翁的痛漸漸地退散）。在 2017 年的演唱會上，則由和他合作多年的 Johnnason Woods 擔任這部分的 Vocal。Roger Waters 和 David Gilmour 他們共有的共識，是這首曲子，當時是由兩人合寫，如今散戲——「Hello, Hello, Hello, is anybody in there?」歸屬 Roger Waters 的著作權。

　　而「there is no pain you are receding」這部分由 David Gilmour 所擁有，因此 David 的演唱會屬於 Roger Waters 的部分，David 曾經邀請 David Bowie 及多位著名歌手甚至是英國著名演員康柏拜曲來演唱。

　　《The Wall》也是一部反戰的概念性作品，當時由 Alan

Parker 執導成一部電影，Alan Parker 是 Roger Waters 和 David Gilmour 同為英國藝術學院前後期的同學。他拍成的電影，成群結隊的德國戰機，忽然變成滿天飛行的十字架，英國國旗也崩落於血泊中，反戰的信息到處可見，Roger Waters 控訴希特勒，這個法西斯主義獨裁者的罪行，法西斯是一種極致國家民族主義的政治運動，在第二次世界大戰前由義大利和德意志第三帝國（納粹德國）建立法西斯政府，後於二戰期間蔓延整個歐洲乃至世界的一套關於創新民族性，及新國民的意識型態，及政治宗教。這是一種獨裁主義的政治運動。

在 1922 年到 1943 年間墨索里尼政權下統治了義大利，包含了納粹主義於第二次世界大戰蔓延整個歐洲，法西斯主義通常結合了社團主義、工團主義、獨裁主義、極端民族主義、中央集權形式的社會主義、反無政府主義、反自由放任的資本主義，法西斯可以視為極端形式的集體主義。1920 年代末西方國家大蕭條所帶來的動亂，使法西斯主義惡性發展，納粹黨迅速膨脹為德國第一大黨。

Roger Waters 在〈The Post War Dream〉中也提到 1913 年九一八事變起，日本走上了法西斯化的道路，在日本以軍部為中心發動侵略造軍艦。「if it wasn't for the nips being so good at building ships. the yards would still be open on the clyde.」

通過天皇制機構，自上而下逐步法西斯化，以適應進一步

擴大侵略戰爭。二戰結束後，作為戰敗國的日本應該受到更為嚴重的制裁。但是，一方面由於美國處於戰略制衡的考慮，一方面人類文明相對進步，對日本的懲罰遠遠沒有人們想像的那麼嚴重。在美國的明示或暗示下，很多國家放了日本一馬，不僅保留了天皇，而且許多戰犯都得以免罪，日本戰俘也被大量放回國內，然而有這麼一個國家，它們對日本最為痛恨，處死了大批的戰犯和戰俘，贏得了世界的尊重，而後被日本後來的電影所嘲諷。這個國家就是澳大利亞，這個國家在戰後痛恨日本到什麼程度呢？

　　首先它要求將日本天皇列為戰犯，美國不同意，最後為了說服它，把極為榮耀的遠東法庭審判長的職務讓給了澳大利亞人威廉‧偉伯。甲級戰犯由遠東軍事法庭來審判，而乙級戰犯由各國自由主處理，沒有哪個國家像澳大利亞一樣，痛快淋漓的處決了一百四十個！（這是日本厚生省的統計）。其次是對待戰俘，由於人數實在太多，各國基本上都選擇了放回日本，但是澳大利亞則不同，他們在新幾內雅島上跟二十萬日軍交戰，其中一萬多日軍投降，澳大利亞人手一揮，全部處死。於是，在二次世界大戰中，凡是在澳大利亞參戰的日本人是最倒楣的，差不多就是死，幾乎沒有活路。說起來，澳大利亞為什麼跟日本有那麼大的仇恨？以致於要如此對日本人痛下殺手呢？說來說去就是兩件事，讓澳大利亞和日本結下了樑子，而這個仇，是怎麼也解不開的了。第一件事是當二戰爆發後，澳

大利亞作為英聯邦國家，有義務跟隨英國出兵。當時他們離亞洲最近，英國就安排他們一起駐守新加坡和馬來西亞，可是日本為了石油資源，瘋狂侵襲東南亞國家的時候，就跟英國和澳大利亞幹上了。有數據顯示，在整個二戰中，澳大利亞被俘士兵有三萬餘人，而這些人中有一半以上是被日本人殺害的了，一次性被日本軍屠殺了近一千人，讓澳大利亞念念不忘，舉國哀痛。第二件事就是日本不僅在其他地區打澳大利亞，日本還曾經侵犯它的本土。

首先是佔領了東索羅門群島，然後，日軍為了顯示自己強大的武力，順勢轟炸了澳大利亞達爾文，造成一千多民平民死亡。這是澳大利亞建國以來，第一次遭遇外敵入侵。澳大利亞人的自尊心一下子就被激發了，以前參戰，可能還是因為英國人的面子，後來他們瘋狂地參加反抗日本法西斯以此為自己的同胞報仇雪恨。在著名的「新幾內亞之戰」中，日軍先後投放兵力達二十多萬，澳大利亞人在這個島嶼上單挑日本，沒有美軍的幫忙，他們基本上全部殲滅了敵軍，據說打掃戰場的時候，為了防止漏網之魚，不管死活，見到日本軍服的都上去補上一槍。日軍在太平洋戰場上出名的瓜島慘敗和應帕爾戰場慘敗，加起來死亡人數不到幾內亞之戰死亡人數的四分之一。這麼算起來，日本其實早就還了殺害澳大利亞人的情，但是在戰後，澳大利亞的種種強硬表現，實在令日本害怕，為此日本人一直記憶猶新，不敢招惹他們。只在1999年舊版的《日本沉

沒》電影中，酸溜溜地說過一句話：「日本要沉沒了，全世界各國都伸出手幫忙，唯獨澳大利亞人在勒索了大量財寶之後別過臉去裝沒事。」你可以說澳大利亞人是有仇必報，也可以說他們以其人之道還治其人之身。不管怎麼說，做了就是做了，反而不少國家表示對他們的尊重和欽佩，如今在國際上名聲倒也不差。

英國也有法西斯聯盟，法西斯主義是一種在特定歷史條件下形成的國際現象，主張建立以超級階級互相標榜的極權主義統治，實行全面統治和恐怖鎮壓，鼓吹民族沙文主義，代表的是社會在經歷一連串經濟動盪，各種民主政府，挽救經濟的手段無效後，經歷中央集權和政府過度干預經濟的惡性循環後，人民訴諸絕對獨裁者的聲浪所必然造成的，如以自然界來說明的話，就類似蜜蜂，或是螞蟻的社會組織，蜂蟻的社會是以整個群體的存續利益為先覺考慮條件。

Roger Waters 用音樂來抵抗人類遺忘歷史的力量，他的音樂翻攪著那些我們逃不掉，藏不住的生命歷史，Roger Waters 的每一部音樂劇作，就是一部歷史，正符合了英國維多利亞時期的愛爾蘭作家奧斯卡王爾德在《身為藝術家的評論者》一書中所說的：「談論一件事比去做更難，這在真實人生已經很明顯，誰都可以創造歷史，但唯有偉大者能寫出歷史。」

Roger Waters 他的每一張的作品彷彿對自己及對世界做出永遠的承諾。Alan Parker 在電影中拍攝嬰兒的哭聲及 Roger 用

小孩的純真的聲音來糾結整個作品的力量，表現出生命誕生的那一刻純粹已開始糾結著歷史，歷史不死，只是過往在 Roger Waters 的作品裡身為戰士，痛苦和驕傲這一生都必需要擁有。

# Another Brick
# in the Wall

## Chapter *07*

## ──只是牆上的一磚

　　不要對自己的缺點太在意，你長大後缺點可能就消失了。

　　法國哲學加盧梭認為，人性本善，但社會造成的不平等狀態進而腐化了人性，因此盧梭認為要讓人類回復本能無垢的本性，必須進行社會認知的改革，需要的是「新式的教育」。

　　Roger Waters 探討的是威權鞭打下的犧牲品。

## ANOTHER BRICK IN THE WALL (PART 2)

**Musicians**

David Gilmour: electric rhythm and lead guitar, vocal harmonies

Richard Wright: Minimoog Prophet-5 Fender Rhode

Roger Waters: vocals, vocal harmonies, bass

Nick Mason: drums

Bob Ezrin: tambourine

Islington Green School Students: choir

**Recorded**

Britannia Row, I slington, London: September 1978 - March 1979

Super Bear Studios, Berre-Les-Alpes, Alpes-Maritimes (France) April-July 1979

Cherokee Recording Studios, Los Angeles: September 6-8 1979

**Technical Team**

Producers:Bob Ezrin, David Gilmour, Roger Waters

Co-Producer: James Guthrie, Nick Griffiths

Sound engineers: James Gurthrie, Nick Griffiths, Patrice Quet, Brian Christian, Rick Hart

搖滾哲思

[Lyrics]

We don't need no education

We don't need no thought control

No dark sarcasm in the classroom

Teachers leave them kids alone

Hey! Teachers! Leave them kids alone

All in all it's just another brick in the wall

All in all you're just another brick in the wall

We don't need no education

We don't need no thought control

No dark sarcasm in the classroom

Teachers leave those kids alone

Hey! Teachers! Leave those kids alone

All in all you're just another brick in the wall

All in all you're just another brick in the wall

"Wrong, do it again!"

"If you don't eat yer meat, you can't have any pudding

How can you have any pudding if you don't eat yer meat?"

"You! Yes, you behind the bike sheds, stand still laddy!"

聽這支作品，可以探討盧梭的著名著作《愛彌兒》，此著

作是當代最具影響力的教育書籍。

　　在盧梭的時代，封建教育是盧梭最為詬病的教育方式，他認為人類因為壓迫的學習方法，使人類的天性窒息了，盧梭所支持的是以「自由發揮」、「接受天性」的教學方法，來培養「自然人」，自然人享受了充分的自由、平等與獨立，是盧梭最為稱頌的自然狀態中所生活的人類。

　　封建的教育對孩子只是揠苗助長，把孩子當作哲學家、神學家一樣的教導，忽略了孩子的自由。

　　在 Roger Waters《The Wall》整部劇作中，可以看到，家庭與學校的環境都是嚴肅的，故事中的主人翁小男生被社會架構框著了，搭配著呈現的螢幕是浩瀚的星空，是我們的思想能力，但卻被囚禁於舊式教育的制度下，教育牽涉的是品味，他是一種生活經驗的累積，無關於身分、地位，更無關乎金錢多寡。

　　從小我們被要求要合群要從眾要跟其他人都一樣，錯了！如果你跟其他人都一樣，既然有那麼多都一樣的其他人，為什麼還要把你生出來，我們每個人被生出來在人間就是因為你跟其他人都不一樣，要欣賞自己的與眾不同及尊重別人的個別差異，在自己的與眾不同之中找到自己的生命意義和價值，因此追求自己的夢想，找到自己的那雙翅膀。[12]

---

[12]　節錄自許禮安醫師〈如何陪伴孩子像陪伴菩薩或天使一樣〉

1973 年《*The Dark Side of the Moon*》提到此一觀念，有關錢的庸俗化，人類要用心用腦去感受而來的生活才是『品味』，品味不與奢華畫上等號是與教育的層級有關，這個世界不只教育出一個個磚塊，模型式的思考體系，連美學都制式化了，Alan Parker 影片中帶著相同面具的孩子們，跟現今社會對美學的制式化，一窩瘋的整形風潮，就像量化式的戴了面具，「自然」不見了。

奧斯卡王爾德說「to be natural is such a very difficult pose to keep」亦即自然是最難維持的姿態。（選自理想丈夫集）現今的社會大家不再珍惜原創的自我，歌曲被翻唱的完全失去原創的意義，如原本藍調的樣貌也可以唱成 rap，原創精神澈底崩解，詞情連不上曲意，是現今音樂最大的落伍。

現代的人內心的「平靜」出了問題，因為無法像 60 年代 Diana Vreeland 所說的你不必生而美麗，也可以充滿魅力，她的定義從來不是世俗標準的價值觀，牙縫名模的始祖 Lauren Hutton 讓不完美成為無可取代的魅力特質，這也是現代人信心落伍的缺憾，當年的 Jannis Joplin、Free、King Crimson、Robert Flipp、Led Zeppelin……充滿個人魅力的時代從 1980 年代開始日漸退化、音樂複製化、人臉複製化、思想複製化、言語複製化，……這是很可怕的腦力萎縮與退化，只因為現代人無法盡可能地誠實面對存在於自身的那個靈魂，真的教育出了問題嗎？或者是出生的世代本身就出了問題？法國哲學家帕斯

卡在他的著作《人是一根會思考的蘆葦》中提到，當你越不用腦時，越是只能藉由外在的表象，或借酒裝瘋等方式來強化自我。

培養人才也不能只看畢業時，而必須看到畢業後的 20、30、40 年，其實學校最怕兩種學生，一種事成績優異名列前茅者，他們可能將來回學校當校長，另一種是成績慘烈，或輟學者，因為之後他們可能回學校演講，如蘋果電腦的賈伯斯；牛津和劍橋大學非常自豪地說，我們把學生當生物，讓生物生長，別的大學把學生當礦物，讓礦物定型，Roger Waters 批評的正是這種定型化的教育，一個好的教育家，會讓過動沒耐性等待未來的孩子放眼去訂製自己的未來。

Roger Waters 筆下的主人翁被教育成為唯唯諾諾害怕做決定的孩子，教育限定了他的成長，科學家們尋找著「邪惡基因」認為邪惡的基因存在霸凌者與被霸凌者的身上，前者無理由的攻擊後者，後者因成長過程缺乏安全感的奶水，其反撲的分裂性人格，攻擊的力量可能如散彈槍式的亂槍打鳥，攻擊社會上的無辜人民，因為他們會以滅絕的方式痛恨人類。

《The Wall》1979 年的作品訴諸的是社會需要給躲在世界角落的受虐童，不論來自學校或家庭的霸凌多一點的關懷，讓他們的傷痛壓力有所轉化，就可以給受難者，劇變者避免悲劇的一再發生。

霸凌的問題存在世界各個角落，至今仍無法有效的解決，

此問題也導致社會問題日趨嚴重，這個社會不是公平的，有太多人正面臨極限的挑戰（critical point），再多一點的侵犯都可能使猛獸撕裂你的最後一次反擊，唯有藝術是可以轉化窒息的靈魂，我們必須將腦內殘念的一切化作藝術。當然《The Wall》最激動人心的演出是在 1992 年倒塌的柏林圍牆的那場演唱會，工作人員隨著全場觀眾齊聲吶喊著「tear down the wall」的喧囂聲中推倒舞台上搭建的高牆，象徵著專制極權的牆終於倒了。

〈Another Brick in the Wall〉（Part 1）描寫 Roger 小時候看著相冊，回憶父親的的一生，他說爸爸飛過了大洋洲，留下的只有回憶，爸爸你還留給我別的什麼嗎？Part 2 的部分是大家所熟知的「we don't need no education」，這一段 Roger Waters 悲劇性的人生成長，每一塊磚都是一個個成長的血淚史，層層圍起了他人生的高牆，他也在牆裡圍起了非常自憐的高姿態，一塊一塊的磚把 Roger 圍住了，圍牆的倒塌象徵蘇聯的解體、東歐的轉制、兩德合併，牆是被推倒了等於強勢被推倒了，但 Roger Waters 的高牆似乎是推不倒的，小時候的陰影通常是影響一個人成長最重要的階段。如〈The Thin Ice〉這個出現在《The Wall》接續著〈Another Brick in the Wall〉的意涵，孩子們你們常常滑倒在自己的深度思想之外，你的恐懼就流露在你的背後，社會上的一切你都如履薄冰的試驗著，如果沒有社會上的嵌制性的教育方式，你的思想可能可以更為偉大。

**THE THIN ICE**

Song by Roger Waters 2 :27

**Musicians**

David Gilmour: electric rhythm and lead guitar, vocal harmonies

Richard Wright: Minimoog Prophet-5 Fender Rhode

Roger Waters: vocals, vocal harmonies, bass

Nick Mason: drums

**Recorded**

Britannia Row, I slington, London: September 1978 - March 1979

Super Bear Studios, Berre-Les-Alpes, Alpes-Maritimes (France) April-July 1979

Cherokee Recording Studios, Los Angeles: September 6-8 1979

**Technical Team**

Producers: Bob Ezrin, David Gilmour, Roger Waters

Co-Producer: James Guthrie, Nick Griffiths

Sound engineers: James Gurthrie, Nick Griffiths, Patrice Quet, Brian Christian, Rick Hart

搖滾哲思

[Lyrics]

[Verse1: David Gilmour]

Momma loves her baby

And daddy loves you too.

And the sea may look warm to you babe

And the sky may look blue

Ooooh baby

Ooooh baby blue

Oooooh babe.

[Verse2: Roger Waters]

If you should go skating

On the thin ice of modern life

Dragging behind you the silent reproach

Of a million tear-stained eyes

Don't be surprised when a crack in the ice

Appears under your feet

You slip out of your depth and out of your mind

With your fear flowing out behind you

As you claw the thin ice

〈The Thin Ice〉開場即以 0:07 七秒處的時候加入了嬰兒的哭聲，這首歌聽起來像搖籃曲，0:59 秒處接上 Richard Wright 的鍵盤彈奏，Roger Waters 把 bass 保持在維持低音的狀態，Roger Waters 在這首曲子中創造了他與 David Gilmour 的緊張處，因為他讓 David Gilmour 的吉他很難找到點觸來彈奏，而且 Roger Waters 把主唱的位置換成是他自己，而 Nick Mason 的 Ludwig Kit 鼓在這首曲子裡展現了如往昔的力道。

英國經驗主義學家洛克認為，人出生時內心如同全新的白紙。正義也會因時代變遷與社會差異而有所不同。洛克並沒有否定神與道德的意義，他認為，人必須依據人的知性來理解，人人都有不同的信仰與認同。但若不知道議論者本身的知識程度，就完全沒有意義，因此談論任何觀念，必須先思量此人的知識能力，也就是洛克談的「認識論」，因此我們的知識由觀念形成，觀念是思考時浮現意識的內容，因此我們的內在最初就如同白紙，是經驗教育為我們提供了意識。

Roger 非常重視教育為下一代帶來的影響力，在演唱會上他請來了 16 位小孩在演唱會上穿著一系列橘色的工人服，到了即興演奏的部分時，他們將橘色制服脫掉，再次呈現內在黑色的力量。Roger Waters 的作品要穿插著聽，就像看電影一般，你的腦要連貫劇情，讓我們再回到《The Final Cut》這張的〈Southampton Dock〉和〈Two Suns in the Sunset〉英國的南漢普頓（Southampton）在二次大戰時士兵多由此出發前往戰區，

他們從 45 號軍艦下船了，他們知道即將展開的是全面性的大
屠殺，這些人犧牲了生命，留下了歷史的塵埃，為下一代留下
的是遍地屍骨及衣冠塚。

**SOUTHAMPTON DOCK**

Song by Roger Waters 2:12

**Musicians**

Roger Waters: vocals, bass

Raphael Ravenscroft: tenor Saxphone

Michael Kamen: Piano, electric piano, orchestra conducting

Andy Bown: Piano, Electric piano

National Philharmonic Orchestra: Orchestra

**Recorded**

The Billiard Room, London: May - October 1982

Hook End Recording Studios

Checkendon: June, October 1982

Mayfair Recording Studios, London: June, October, November
1982 January 19, February 1983

Olympic Studio, London: June, October, November 1982

Abby Road Studio, London: July 22, 23 1982

Eel pie Studios, Twickehen: September 1982

RAK Studios, London: October 1982

Audio International Studios, London: January26-30 1983

**Technical Team**

Producers: Roger Waters, James Guthrie, Michael Kamen

Sound Engineers: James Guthrie, Andy Jackson

Assistant Sound Engineers: Andy Cannelle, Mike Nocito, Jules
Bowen

[Lyrics]

They disembarked in 45

And no-one spoke and no-one smiled

There were to many spaces in the line.

Gathered at the cenotaph

All agreed with the hand on heart

To sheath the sacrificial Knifes.

But now

She stands upon Southampton dock

With her handkerchief

And her summer frock clings

To her wet body in the rain.

搖滾哲思

In quiet desperation knuckles

White upon the slippery reins

She bravely waves the boys Goodbye again.

And still the dark stain spreads between

His shoulder blades.

A mute reminder of the poppy fields and graves.

And when the fight was over

We spent what they had made.

But in the bottom of our hearts

We felt the final cut.

　　西方霸權就這樣輕易地揮霍掉「和平」，Roger Waters 引
用了印度詩人歐瑪凱因（Omar Khayyam）的 bitter joy 理念來形
容軍人，一方面保衛國家一方面葬送生命的心理狀態，歐瑪
凱因完全不相信宗教上對於人死後會有 72 位處女在天上等著
你，我想這是宗教上最荒謬的想法吧！怎麼人死後的靈魂是這
麼的肉慾，真的不知道這樣的意義何在？那女人死後呢？72
位處男在天上等著嗎？人是何等的沒有思想能力啊，即使是揣
測死後靈魂的去處竟是這麼的膚淺，真是令我啼笑皆非，這更
不是那些為國捐軀的士兵們的靈魂想要歸屬的目的吧！

　　雖然歐瑪凱因的主張要及時行樂，但 Roger 是完全反對

bitter joy 的理念。Roger Waters 的思想介於法國思想家笛卡兒和哲學家帕斯卡之間，他認為人具有「纖細心智」，意指人類具有宗教情懷，帕斯卡對人類的悲慘和偉大在他的《沉思錄》中可窺見，人位於無限的中間，和廣大自然比起來，「人類漂泊一隅，幾乎渺小到無」所以，以無限來看人類等於無，但相對於無，人類又是全部，亦即處於無和無限之間，在這個學說之下，Roger Waters 證明了帕斯卡的哲學，人類是很脆弱的，一不小心就會陷入想要「解悶」的狀態，就如歐瑪凱因的「散心」狀態，在〈Paranoid Eyes〉可以看到人最脆弱的一面，人在恐懼中是完全喪失思考能力的。瞭解法國後現代哲學家德勒茲，可以幫助我們瞭解 Pink Floyd 談精神分裂的狀態區分 Paranoid 偏執狂跟 Lunatic 精神分裂的不同。

偏執狂是會統合性的掌握事物，會持續煽動慾望，而 1973 的《The Dark Side of the Moon》中的〈Brain Damage〉談的是精神分裂是 Lunatic，是忽然撇見潛意識世界的人。德勒茲主張，在資本主義世界裡，不要受制於特定的價值觀，應該要向精神分裂者一樣，試著從各個角度獲得不同的體驗（請參考作品《The Dark Side of the Moon》中的〈Money〉）。Roger Waters 他在〈The Fletcher Memorial Home〉中提到另一個恐怖主義即 the ghost of Macarthy 這是美國冷戰時期的恐怖反共主義風潮，泛指 1917-1920 年間布爾什維克主義和無政府主義引起的廣泛恐懼，源自第一次世界大戰後，過度蓬勃的「國家主義」。

## THE FLETCHER MEMORIAL HOME

Song by Roger Waters 4:12

**Musicians**

David Gilmour: electric rhythm guitars

Roger Waters: vocals, bass

Nick Mason: drums

Ray Cooper: tambourine

Raphael Ravenscroft: tenor saxphone

Michael Kamen: piano, electric piano, orchestra conducting

Andy Bown: piano, electric piano

National Philharmonic Orchestra: orchestra

**Recorded**

The Billiard Room, London: May - October 1982

Hook End Recording Studios

Checkendon: June, October 1982

Mayfair Recording Studios, London: June, October, November,

1982 January 19, February 1983

Olympic Studio, London: June, October, November 1982

Abby Road Studio, London: July 22, 23 1982

Eel pie Studios, Twickehen: September 1982

RAK Studios, London: October 1982

Audio International Studios, London: January26-30 1983

**Technical Team**

Producers: Roger Waters, James Guthrie, Michael Kamen

Sound Engineers: James Guthrie, Andy Jackson

Assistant Sound Engineers: Andy Cannelle, Mike Nocito, Jules
Bowen

[Lyrics]

Take all your overgrown infants away somewhere

And build them a home, a little place of their own.

The Fletcher Memorial

Home for Incurable Tyrants and Kings.

And they can appear to themselves every day

On closed circuit T.V.

To make sure they're still real 。

It's the only connection they feel 。

"Ladies and gentlemen, please welcome, Reagan and Haig,

Mr. Begin and friend, Mrs. Thatcher, and Paisly,

"Hello Maggie! "

Mr. Brezhnev and party。

"Who's the bald chap?"

The ghost of McCarthy,

The memories of Nixon.

"Good-bye!"

And now, adding color, a group of anonymous latin-

American Meat packing glitterati.

Did they expect us to treat them with any respect?

They can polish their medals and sharpen their

Smiles, and amuse themselves playing games for awhile。

Boom boom, bang bang, lie down you're dead.

Safe in the permanent gaze of a cold glass eye

With their favorite toys

They'll be good girls and boys

In the Fletcher Memorial Home for colonial

Wasters of life and limb。

Is everyone in?

Are you having a nice time?

Now the final solution can be applied.

　　第二段的紅色恐慌為發生在 1950 年代初的麥卡錫主義，
在麥卡錫時代，不少美國人被指認為共產黨人或同情共產主義

者，在沒有足夠的證據的情況下被指控不忠於國家，背叛顛覆，叛國等罪，也被稱為紅色恐慌（Red Scare），被迫在政府或私營部門委員會等地，接受不恰當的調查和審問。在美國興起全國性的反共「十字軍運動」。1954 年 Macarthyism 達到巔峰，許多人被判死刑坐上電椅。

## ONE OF THE FEW

### Musicians

David Gilmour: electric rhythm guitars

Roger Waters: vocals, bass

Nick Mason: drums

Ray Cooper: tambourine

Raphael Ravenscroft: tenor saxphone

Michael Kamen: piano, electric piano, orchestra conducting

Andy Bown: piano, electric piano

National Philharmonic Orchestra: orchestra

### Recorded

The Billiard Room, London: May - October 1982

Hook End Recording Studios

Checkendon: June, October 1982

Mayfair Recording Studios, London: June, October, November 1982 January 19, February 1983

Olympic Studio, London: June, October, November 1982

Abby Road Studio, London: July 22, 23 1982

Eel pie Studios, Twickehen: September 1982

RAK Studios, London: October 1982

Audio International Studios, London: January26-30 1983

**Technical Team**

Producers: Roger Waters, James Guthrie, Michael Kamen

Sound Engineers: James Guthrie, Andy Jackson

Assistant Sound Engineers: Andy Cannelle,Mike Nocito Jules Bowen

[Lyrics]

When you're one of the few,

To land on your feet.

What do you do to make ends meet?

(Teach)

Make 'em mad

Make 'em sad

Make 'em add two and two

Make 'em me

Make 'em you

Make 'em do what you want them to

Make 'em laugh

Make 'em cry

Make 'em lay down and die

　　Roger Waters 似乎是笛卡兒的信徒，在〈One of the Few〉中的「make them mad, make them sad, make them add two and two 這個哲思來自於這個現實世界許多感覺都是不可信的，笛卡兒認為憑感覺得到的資料都是不確實，而 Roger Waters 認為人在極度壓力及恐懼之下所感覺到的事物更是扭曲的，即使像 2+2 這種簡單的計算，也有可能只是惡魔刻意讓我如此計算的，笛卡兒主張澈底的懷疑一切之後，所理解到的事才有可能是真理，也許 Roger Waters 和笛卡兒的懷疑有些過了頭，但他就是澈底懷疑到這種程度。

　　但 Roger Waters 對於思考中的「我」是存在的事實，與笛卡兒的「我思故我在」是有所區別的。Roger Waters 的我是屬於偏執狂的我，創作中的他就像演員一樣演出了偏執狂的腦內思想，他成了非常敬業的演員，創作中的他成了瘋子，而他也能清楚地知道如何與他創作出來的瘋子和平共存。Roger Waters 擅長概念性的創作，一整張專輯必須在你腦內交錯的聽，聽到

〈One of the Few〉要想到〈The Gunner's Dream〉剛剛有提到什麼才能串連出下一首的詞「when you're one of the few to land one your feet」。

注意到他提到的《Angel of Five》這是一部 1950 年代的電影，講述的是二次大戰時英國空軍與德軍在 Dresen 交戰的故事，因此我們就能理解他為什麼以〈One of the Few〉來形容落入敵軍時的恐懼感。

在《The Final Cut》這首標題曲裡，他認為女人與社會一樣的拒絕他、傷害他，他再次提到「我被惡劣對待，但我不畏懼死亡」。

其實每一個人一出生就注定了走向死亡，所以我們應該思索的問題是如何活？就如同你無法選擇生一樣，我們也無法選擇怎麼死，每個人都是哭著來到這個充滿痛苦的世界，南丁格爾曾經說「如果你要揭露這個世界的風塵，那麼你就注定得灰頭土臉」。

如何活成了最大的課題，因為我們無法選擇如何死，但你可以選擇如何活，Roger Waters 的作品探討許多跟死亡有關的議題。

曾經聽過這麼一場演講，有關生死學，提到所有還活著的人只有今天因為明天到來時就又變成今天，海德格哲學說到每個人都無從選擇的被丟到這個世界來，如果可以選擇，很多人一定不想生在這樣的國家或家庭或生成這樣的人，但，我們就

是毫無選擇的被生出來又毫無選擇的死去。Roger Waters 一再強調的，死不足為懼，如何死的有意義才是最重要的人生課題。他將性的苦楚放大了社會的不公。

　　古希臘神話裡得遇密蹟者才能治癒性的障礙，在理論上體認到「我對自我何其陌生」，當今的心理學家佛洛伊德認為一旦你能發現自我的性慾特性，你就知道自己是誰。

　　Roger Waters 寫下的 making love to magazine，青春期，本來就是性摸索期，尋求安全感與自我認同感。 Roger Waters 以一種全球化的方式幫助他自己及你我尋找答案。

　　歌迷對 Roger Waters 的執著，在追尋自我認同的過程裡，Roger 是我們可以仰望的善意形象，誰能像他一樣 73 歲還能吸引上萬名群眾來到他的國度，他的懷抱，無論脆弱、恐懼、怨恨、挫折……將這些全然以搖滾的方式掙脫，以平行的方式獲得解答！

# Dark Side
# of the Moon

# Chapter 08

## ──溫吞月光

　　1973 年出的作品《*The Dark Side of the Moon*》（從 1972 年六月錄到 1973 年一月發行）這是一張充滿精神壓力與現世時間軸的接續性故事，虛構反映真實，太空纏繞銀河滴淚。引用樂團 Velvet Underground 的一句話：「若討論這世界是怎麼樣的，則音樂是用創造出的音色來神聖結構，使得所有的痛苦與磨難變得比較容易承受。」

　　這張作品讓重視實驗的 Pink Floyd 在商業上找到了成功的定位，當 Alan Parsons 參與了音效錄音的工程時（在 Abby Road

Studio 錄製，這間錄音室錄製出無數的偉大作品），Roger Waters 曾經表示：「這張作品是一支搖滾樂團對成長的考驗與足跡。」唱片一問世即以催魔狂般的魔力吸引著樂迷一起經歷異常詭譎的瘋狂幻想。〈Time〉是一部非常棒的作品，由四位團員共同創作全長七分六十四秒。Dave Mason 非常特別的鼓著落點長達兩分二十七秒，再以大鼓帶出 ticking away that moments that make up a dull day ...〈Time〉逐漸熬出時間的苦汁，虛構的人物卻是來自自己的生命配合著 Roger Waters 的宇宙美學觀點，Roger Waters 要禪述的宇宙是，時光飛逝，而人生存的原因又在什麼地方呢？也許時間最終會告訴每個人生存的意義，但也許一切為時已晚，所以 Roger Waters 的偉大並不是對世界的批判和嘲諷，而是要每個人能清楚地揭示自我，才是他寫〈Time〉最大的誠意。

我們在 Roger Waters 的作品中可以看見他的人生路途諸多悲慘的情節，不過所有的悲傷情節，無非是考驗一個人臨弱的本能，尤其要在尊嚴與況落之間拿捏清楚著實不易。

**BREATHE**

Song by Roger Waters, Davaid Gilmour, Richard Wright 2:50

Breath, breathe in the air

Don't be afraid to care

Leave but don't leave me

Look around, choose your own ground

For long you live and high you fly

And smiles you'll give and tears you'll cry

And all your touch and all you see

Is all your life will ever be

Run, rabbit run

Dig that hole, forget the sun

And when at last the work is done,

Don't sit down, it's time to dig another one

For long you live and high you fly

But only if you ride the tide

And balanced on the biggest wave

You race towards an early grave

　　〈Breath〉的最後賦予他據與擬人化，這是一首在 1970 年時作的曲子，當時 Roger Waters 和 Ron Geesin 有不同的意見而沒有收錄進當時的作品集裡，直到 1972 年 Roger Waters 聲稱這是一首對自己有所「規勸」的曲子，有關一個人對於人生路途的過去及未來應如何抉擇的問題探討。

　　「breath」也象徵「birth」，出生到這個世界如何讓自己

能夠有意義的活著，這首作品被詮釋為未成年人對青年們的告誡。

　　Roger Waters 說到，他做這首曲子時深受 Neil Young 的《*Down By the River*》1969 年的作品〈Everybody Knows This is Nowhere〉且同時用了 E 小調及 A 和弦來完成此曲，他同時也感謝 Richard Wright 帶來不同色彩的音樂片段。

　　他們在曲中加入了心跳聲，Richard Wright 也很讚賞 David Gilmour 的重複錄製吉他，因為他是整個團裡最重要的吉他手，他當時用的是 Fender 1000 型號來彈奏，並滑動平台式的吉他演出全作品，相當出色，Richard Wright 回應著 David Gilmour 的吉他，Richard Wright 用的是 Wurlitzer EP-200 型號的鍵盤音色，並透過 Leslie 音響錄製，他雙手彈著兩台 Hammond RT-3 管風琴。

**Musicians**

Roger waters: bass VCS3

David Gilmour: vocals, voal harmonies electric rhythm and lead guitar, EMS HI FI VCS3

Richard Wright: vocals, keyboards VCS3

Nick Mason: drums rototoms

**Recorded**

Abby Road, Studio, London, June 8-10, 20, 22, October 17, 31,
November 1972 january21, 24, 25 1973

**Technical Team**

Producer: Pink Floyd

Sound engineers: Alan Parsons, Chris Thomas

Assistant Sound engineer: Peter James

　　〈Time〉看著時間的沙漏流逝，這就是生命，想不脫離生命的安排似乎不容易，如果我們以義大利哲學家喬瓦尼皮科的看法來討論時間與人生的話，他認為正因為人擁有自由意志，所以人能做到任何事，也才能創造自身的命運。古希臘把宇宙視為大宇宙（macrocosmos）而把人類的身體看作小宇宙（microcosmos）彼此相對應，智者的精神是小宇宙，和大宇宙相對應，文藝復興是希臘思想的復甦，所以如何能在有限的生命時間裡將生命層次提升而品嚐各種滋味是 Roger Waters 的驅力。

**TIME**

Song by Roger Waters, Nick Mason, Richard Wright, david
Gilmour 6:53

**Musicians**

Roger waters: bass VCS3

David Gilmour: vocals, voal harmonies electric rhythm and lead
guitar, EMS HI FI VCS3

Richard Wright: vocals, keyboards VCS3

Nick Mason: drums Rototoms

**Recorded**

Abby Road, Studio, London, June 8-10, 20, 22, October 17, 31,
November 1972 January 21, 24, 25 1973

**Technical Team**

Producer: Pink Floyd

Sound engineers: Alan Parsons, Chris Thomas

Assistant Sound Engineer: Peter James

[Lyrics]

[Verse 1: David Gilmour & Richard Wright]

Ticking away the moments that make up a dull day

You fritter and waste the hours in an offhand way

Kicking around on a piece of ground in your home town

Waiting for someone or something to show you the way

Tired of lying in the sunshine staying home to watch the rain

You are young and life is long and there is time to kill today

And then one day you find ten years have got behind you

No one told you when to run, you missed the starting gun

[Verse 2: David Gilmour & Richard Wright]

And you run and you run to catch up with the sun but it's sinking

Racing around to come up behind you again

The sun is the same in a relative way but you're older

Shorter of breath and one day closer to death

Every year is getting shorter, never seem to find the time

Plans that either come to naught or half a page of scribbled lines

Hanging on in quiet desperation is the English way

The time is gone, the song is over

Thought I'd something more to say

["Breathe" reprise: David Gilmour]

Home, home again

I like to be here when I can

And when I come home cold and tired

Its good to warm my bones beside the fire

Far away across the field

The tolling of the iron bell

Calls the faithful to their knees

To hear the softly spoken magic spells

「真實的本質」彷彿就會在靈光乍現的片刻，以虛幻的形式展現真實，在《The Dark Side of the Moon》中，對太陽其實是並不歌頌的，他形容月亮永遠陰暗的那一面，在文學上則有著莎士比亞十四行詩的意味，「寧可窮困，也不願面面稱王」，另一則意義，是可以從侷促的滴答鐘聲感受到時間分秒流逝的壓迫感，蒼穹的多變樣貌，一以貫之的循環定率，向來就具有警示語言的特質，不追秒、不追分、不追時日……年輕人荒誕度日，數十年後當你回首恍然大悟，為時已晚，有著少不努力老大徒傷悲的悔恨，流失了所有的歲月，就連日月本身也隨著光年而日漸催朽。

王爾德在理想丈夫書中提到「沒有人能富有到贖回過去」因此 Roger Waters 希望年輕人要有捍衛做夢的勇氣，不要因為沒有彩虹而責怪雨，一個人對某樣知識有了足夠的認識或理解後，他就有資格耍幽默，而我們對宇宙科學的了解應該還在被宇宙耍的階段。

《The Great Gig in the Sky》（因為是概念專輯，因此我們書寫的方式就如進入他們的腦內思想及聆聽他們的曲目一樣，我

們不分章節來介紹而是一氣呵成）。

這一首是由鍵盤手 Richard Wright 擔綱讀寫的作品，請來 Clare Torrys，成果非常成功，Clare Torrys 這位白人試唱錄音一次完成，發自深層心底的獨自吶吟，精彩至極，至今無人能超越，令人窒息的吶吟，曲中 Roger Waters 口述「and I am not frightened of dying, any time will do, I don't mind why should I be frightened of dying? Theres no reason for it. You've gotta go some time.」

這樣的詞讓我們再次發覺西賽羅的學說在 Roger Waters 的作品裡屈居要角「接近死亡不必畏懼，這是人生必經之路，重要的是人生是否過得充實？」在出生之前，你我都已是英雄，預知生命行走的路徑死亡與孤獨的課題是必修學分，死亡其實就像一道旋轉門，實際上沒有太大變化，拋開肉體型態，仍會保有精神的型態（更多的有關此議題的探討可參閱聆聽 Roger Waters 於 1992 年九月發行的《Amuse to Death》，要成為精神層次高的人，通常要孤立自己，所幸今日搖滾有享受苦行憎的日子。孤獨甘之如飴，David Gilmour 說道：「當 Roger 創作時總是將自己孤立起來達數週之久，再碰面時就又有新作品誕生。」

對於創作者而言孤獨是一種創作時所產生的力量，alone 並不等於 lonely 每個人來到這個世界都必須接收各種命題的恐懼，最終將成為勇敢的獨行者。優秀的搖滾作品影響或許

不在即刻，但卻是可以遠久無行地影響我們的人生，從 Pink Floyd 到 Roger Waters 的哲學思考裡，我們在《*The Dark Side of the Moon*》這張作品裡找到了生命裡各項的衝擊點，專輯封面的彩虹射線，這個立體的三角錐在 Pink Floyd 的人生光影學裡，是一個在絕對時候最安全的緩衝區。（在 2017 年的演唱會中，當唱出〈Brain Damage〉及〈Eclipse〉時打出雷射三角錐，光彩奪目，you are on the dark side of the moon）

**BRAIN DAMAGE**

Song by Roger Waters 3:47

**Musicians**

David Gilmour: electric rhythm and lead guitar

Roger Waters: vocals, vocal harmonies, bass

Richaard Wright: keyboards

Nick Mason: drums

Doris Troy, Lesley Duncan, Liza Strike, Barry st, John: backing vocals

Peter Watts: voice

**Recorded**

Abby Road Studios, London: June 2-3, 6, 20, October 11-12, 17,

November 2-3 1972 February 1, 9 1973

[Verse 1: Roger Waters]

The lunatic is on the grass

The lunatic is on the grass

Remembering games and daisy chains and laughs

Got to keep the loonies on the path

The lunatic is in the hall

The lunatics are in my hall

The paper holds their folded faces to the floor

And every day the paperboy brings more

[Chorus 1]

And if the dam breaks open many years too soon

And if there is no room upon the hill

And if your head explodes with dark forebodings too

I'll see you on the dark side of the moon

[Verse 2]

The lunatic is in my head

The lunatic is in my head

You raise the blade, you make the change

You rearrange me 'til I'm sane

You lock the door

And throw away the key

There's someone in my head but it's not me

[Chorus 2]

And if the cloud bursts, thunder in your ear

You shout and no one seems to hear

And if the band you're in starts playing different tunes

I'll see you on the dark side of the moon

[Outro]

I can't think of anything to say except

Hahahahahahaha!

I think it's marvelous!

Hahaha

　　整部作品呈現的是壓力的張力，〈Brain Damage〉中將曲中的主人翁涉入創作以 lunatic 的悲劇角色來看患者的心境，世界總是給人們一連串的驚恐與打擊，失心瘋的他，其生命被「悲慘」兩個字緊緊得抓住，他們看不到正常人所能看到的未來，因為腦袋裡總有巨大的橫樑壓著。

搖滾哲思

Pink Floyd 的作品每一部都是一則哲學性的思考，〈Brain Damage〉纏繞著 lunatic 而跑，歌詞如電影般，一開始瘋子出現在草地上，再來出現在家裡的大廳，最後出現在大腦裡，暗示自己即是那個瘋子，Alan Parsons 使用一種陰沉詭譎的笑聲，將腦內的瘋子以回音的方式釋放出來。在 Roger Waters 筆下有關醫學方面的解釋是「腦前葉切除術後的人」，他們的推理、語言表達，及情緒都與正常人不同。以 Pink Floyd 他們的手法來聽這首作品的話，必須與〈Eclipse〉一起談，要能聽到他們曲子的精髓必需要能看懂聽懂那些穿插情節的曲子。

Roger Waters 筆下的「笑」真能釋放最大的壓力嗎？笑是腦部最大自由的表徵嗎？但這個笑如果是出於腦前葉額已經嚴重毀損的狀態下，則此「笑」並非是所有壓力的釋放，反而是扣住了壓力。Roger Waters 在詞中提到每天送報童將那些政客的嘴臉折疊於一堆堆的報紙上，送到你的眼前，一大堆的政客在你的腦海裡，那個腦已經不是你原本的腦了，你已大量被洗腦，原本在你腦內的東西你喊得再大聲也呼喚不出來了，你的腦就像月球永遠陰暗的那一面，所有的人不再以真面目示人……哈哈哈哈哈哈哈……（令人毛骨悚然的笑聲來自神經病患的笑……）社會的種種病態，掐著你的血脈，窒息你的腦部呼吸。

Roger Waters 說明分裂性人格的生命與情感是沒有任何交集，當不同的經歷和人格特質融入他的感覺之中時，他們沒

有一絲快樂的感覺，由於缺乏與別人的情感互動，因此也缺乏處事的中間色彩，分裂人格者的行為，是他們所有心靈印象的總和，也就是「恐懼的總和」。心理學家費茲里曼（Fitz Liman）研究的個案中有位病患描述到「恐懼是他們認知的唯一實情」，但這樣的人喜歡孤獨，而且才華洋溢，其中不乏極有天賦的天才型人物，孤獨與寂寞成了正面的價值。

我說過這是一個可怕又可敬的成長過程，這股力量如果沒有好好釋懷的話，會變成一股巨大的催毀力，傷害自己也傷害別人，他們會看到自己黑暗的那一面不斷湧現自私、嫉妒、懷疑、不信任、埋怨……等，小時候不好的經驗烙印在他們的心理，陰影也一直都在，造成他們動盪的靈魂。

他們的問題來自於社會，還諸於社會。〈Us And Them〉選自 Pink Floyd 1973 的《The Dark Side of the Moon》，2017 年在費城的演唱會上他站到了距離我最近的位子，演唱著這首由 Roger Waters 與 Richard Wright 共同創作的曲子，這是一首我很喜歡的作品之一，我興奮地揮動著雙臂，他也舉起手向觀眾致意，這首曲子最初是由鍵盤手 Richard Wright 以鋼琴旋律譜曲，為 Michelangelo Antonioni 1970 年的電影 Zabriskie Point 做的電影配樂，不過並沒有得到青睞，一直到 1973 年的專輯發行時由 Roger Waters 填上詞意，Michelangelo Antonioni 才注意到這首曲子，有道是隔行如隔山，導演的選曲功力有時並不一定敏

銳，所幸《*The Dark Side of the Moon*》的成功讓 Richard Wright 的才華不至於被埋沒，類似這樣的事件屢屢出於如製作人、出版商、導演等等⋯⋯他們的抉擇常常決定了一位天才的日出與日落，〈Us And Them〉剛好談的是抉擇的問題，對於戰爭與身家財產的選擇是需要智慧的運作，畢竟我們都只是平凡人，你和我、我們和他們、黑與藍、上或下、左或右，人生就是一連串的抉擇，有誰知道任何的抉擇是對是錯？

〈Us And Them〉告訴我們的是，這些問題無法在平行時空獲得解答。上帝也只知道，這不是我們應該做的抉擇，祂背對著我們哭泣著⋯⋯而前排的士兵已先慷慨就義了，將軍按圖索驥，坐鎮指揮，死了一排再來一排。Roger Waters 說「每次的抉擇就像打了一場仗」，「haven't you heard, it's a battle of world」，徵才徵兵的廣告總是把哭泣隱藏起來，一位心境已老死的老者對他的孩子說：「在你的內心裡一定要保留著空間，給自己一些決擇的轉環」。

搖滾哲思

*Big Man,*
*Pig Man*

*Chapter 09*

## ──那隻著名的空氣豬出現了

　　從 1977 年起當他們第一次發表《*Animals*》的現場演唱時就飄著這隻空氣豬，當然 2017 年 7 月 8 月的演唱會上它絕不缺席，空氣豬繞著全場在上空飄著，隨著曲子〈Pigs〉(Three Different Ones)而出現。首先開場的「Big Man, Pig Man」，Roger Waters 把豬當成了這世界這社會的主宰，是在這個社會中最上流社會階層的那些人，dogs and sheep 成了被豬統治的人物，這首曲子的關鍵字「stone」代表人們的沉淪，資本主義體制下的社會，不管任何工作層級，就算你再有思想，再有才華，只要

與商業相抵觸你就是「無用論」底下的犧牲品。而且血液核心都變成鐵石心腸在 blood become into stone，Roger Waters 把狗與狼視為同科，所以在他的創作筆下，狗並非我們一般所熟知的可愛形象，牠代表是商人們或政客們善用的 dirty trick（骯髒的伎倆），而人們所能達到的最高層級就是那隻豬，川普穿著尿布的影像出現在環繞的螢幕，Roger Waters 唱著「charade you are」（即用手勢玩猜謎的比手畫腳遊戲）比喻川普的幼稚無知，美國有一個反諷川普的節目叫《*The President Show*》，秀裡常常會出現川普興奮地玩著這個遊戲，這也是川普最愛玩的遊戲，也用來比喻川普在商業形勢下一路追求名與利，就像歌曲中的主人翁一生都活在普世的價值觀底下，累得跟狗一樣，一生都為了勉強表現自己「很出眾」而執著於追求名聲、人氣、財富、地位與權力……

　　他還寫出了大大的字幕在螢幕上 Trump is a Pig，故事的主人翁覺得所生活的一切都跟物質有聯繫，覺得自己是那個物質世界的一部分，動物別無選擇，只能跟著他的自然走，但是人類應該試圖去改變或隱藏他們的自然，動物不會從事情中製造難題，但是人類會，因為這些的種種而壓力纏身造成精神耗弱，因為慾望的過多而造成的積勞成疾，其實人生任何的選擇都意味著要放棄另一些東西。我們應該去找到那個內在非常平凡的地方，接受本然的事實，不為其他理由，跟存在保持和平的狀態，因為跟本然的抗爭就會惹來痛苦，學習放鬆似乎是故

事的主人翁無法做到的事，單單只要成為自己就好，聽取自己身體的經驗，顯然他是沒辦法的。

　　也許他來自有太多規範要求的父母，如果他想要存活，並得到他們想要的，就必需要非常小心於自我規範及表現，這是一個關於生存的問題，是作為相對於只是存在的問題，保持忙碌而來壓抑心中的緊張及不安全感。

　　我們在這個環境下，為了保持安全感，只能認同社會的價值觀，因為被指責有了夢想就自以為自己長了翅膀，從小我們被要求要合群要從眾要跟其他人都一樣，遭到「害怕被看輕」的恐懼所控制。他認為社會是一種交易他們的給予是為了要得到，當那些期望沒有被滿足，他們就會責怪別人，或是責怪社會和周遭的環境，過度堅持他們認為對的事情幾乎到了病態的程度，這使得他們非常善辯，Roger Waters 諷刺白宮裡的政客，總認為自己的觀點是對的，「Big Man, Pig Man」；而盲目到無法看見別人的觀點，所以很明顯對方的觀點一定是錯的，那個在純粹狀態下的真理品質，可能變成世界上諸多錯誤的主要肇因。

**PIGS ON THE WING (PART 1)**

Song by Roger Waters 1:26

**Musicians**

Roger Waters: vocals, acoustic guitar

Snowy White: lead guitar

Nick Mason: drums

**Recorded**: Britannia Row, Islington, London: April-December
1976

**Technical Team**

Producer: Pink Floyd

Sound Engineer: Brian Humphries

Assistant Sound Engineer: Nick Griffiths

[Lyrics]

If you didn't care

What happened to me

And I didn't care for you

We would zigzag our way

Through the boredom and pain

Occasionally glancing up through the rain

Wondering which of the

Buggers to blame

And watching the pigs on the wing

　　這首曲子在錄製第一軌時 Brian Humphries 將 David Gilmour 的吉他 solo 換掉改由 Snowy White 彈奏 49 秒，他所使用的為 1957 年製造的 Gibson Les Paul Gold top 透過 Vox AC30 擴大器來彈出，David 沒有參與到此次的錄製，對此 David 也相當的不悅，因為他已經創做出來而且也錄好了，竟然被錄音工程師 Brian Humphries 給撤換掉。

　　這首曲子錄製 1977 年 2 月由 EMI 發行。

## PIGS (THREE DIFFERENT ONES)

### Musicians

Roger Waters: vocals, vocal harmonies, VCS3

David Gilmour: electric rhythm and lead guitar bass guitar, sound effects

Richard Wright: hammond organ ARP solina piano claviner, minimoog VCS3

Nick Mason: drums, cowbell（西部像牛鈴一般的樂器）

**Recorded**: Britannia Row, Islington, London: April - December 1976

**Technical Team**

Producer: Pink Floyd

Sound Engineer: Brian Humphries

ASE: Nick Griffiths

[Lyrics]

Big man, pig man

Ha, ha, charade you are

You well heeled big wheel

Ha, ha, charade you are

And when your hand is on your heart

You're nearly a good laugh

Almost a joker

With your head down in the pig bin

Saying 'Keep on digging'

Pig stain on your fat chin

What do you hope to find

Down in the pig mine?

You're nearly a laugh

You're nearly a laugh

But you're really a cry

Bus stop rat bag

搖滾哲思

166

Ha, ha, charade you are

You fucked up old hag

Ha, ha, charade you are

You radiate cold shafts of broken glass

You're nearly a good laugh

Almost worth a quick grin

You like the feel of steel

You're hot stuff with a hatpin

And good fun with a hand gun

You're nearly a laugh

You're nearly a laugh

But you're really a cry

Hey you, Whitehouse

Ha, ha, charade you are

You house proud town mouse

Ha, ha, charade you are

You're trying to keep our feelings off the street

You're nearly a real treat

All tight lips and cold feet

And do you feel abused?

You got to stem the evil tide

And keep it all on the inside

Mary you're nearly a treat

Mary you're nearly a treat

But you're really a cry

在這首作品中 Roger 把 pigs 分成自由社會中的三種層次的人物。

第一種是商人，穿著三層式內有背心型的西裝，抽著雪茄，喝著威士忌，他寫道「when your hand is on your heart you're nearly a good laugh, almost a joker」，他認為富人如果沒有做些對公益有益的事，那有錢人的一生簡直是個笑話，腦滿腸肥的感覺。

第二種是他腦袋裡面玩弄特權的女人，有些女人具有交際手腕及操弄大局的性格，他指的就是 Margaret Thatcher，英國首相柴契爾夫人，雖然當 Roger Waters 在寫這首作品時她還沒有當上首相，但 Roger 已預知，以她政治謀略操控議會的方式，勢必會穩上。

第三種是象徵刻薄的人性指的是 Marry Whitehouse 她是一個藝術學的老師，她有著壞脾氣，認為這個社會應該由宗教統治而非政治，她把自己聖人化認為這個社會太骯髒了，她認為自己是社會自由黨的人，她用當時的一部電影《*A Clock Work Orange*》（1971）比喻自己為聖人，此部電影由 Stanley Kubrick 拍攝。

Roger Waters 認為人類「想要」的事物太多了，這造成了

人生痛苦的由來，其實人生除了痛苦什麼都不是，而且是用所有的傷口經驗換來的，許多事刻意未必最美，隨意才叫真生命，當你珍惜自己的過去，滿意自己的現在，樂觀自己的未來時，你就站在了生命的最高處。

當你明白了成功不會造就你，失敗不會擊垮你，平淡不會淹沒你時，你就不再受那隻象徵上流社會的豬掌控，如果你想成為一個成功的人，那麼請為自己加油，讓積極打敗消極，讓真實打敗虛偽，讓寬容打敗褊狹，讓快樂打敗憂鬱，讓勤奮打敗懶惰，讓堅強打敗脆弱，只要你願意，你完全可以做最好的自己（摘自滿願大準提）此時讓我想起了一首詩經《魏風‧園有桃》歷來，爭議頗多，莫衷一是〈毛序〉言「刺時也」，一說為晉文公重耳祭調之推的詩。

吾傾向「士大夫憂時傷己，懷才不遇」之詩。說的是戰國時期魏文侯的老師田子方，見園中桃，棗果實尚可供人喫食，自己身負大才卻不被重用，還為時人，誤解其高傲和反覆無常，心中憂憤難平。

綜觀古今中外，多少臣臣子子憂心於懷才不遇而積勞成疾，如果人類能順其自然不要有過多的得失心，學學老莊思想的「無為自然」。

Roger Waters 對於中國的政治哲學也有許多的探討（參考1992 年的作品《Amuse To Death》將於後面章節談論）。

現代的人因為處於處處緊張的生態下，人們在生命的天平

上已嚴重到失衡的狀態，為求生存，為求存活，求名求利這樣的人生一點意義也沒有，如此的人生只為滿足無限衍生的慾望，當世界上的慾望彼此衝突時，鬥爭、戰爭就發生了。

德國哲學家叔本華認為，假如人生想追求的東西太多，無止盡但最終什麼也得不到，那麼人生的本質就是苦惱，一切努力終歸徒勞，Roger Waters 在《Animals》的作品中的主人翁將所有的欲求都加諸在他自己身上，每一個欲求就有如身上綁了塊重石，越來越沉重，全身上下綁滿了重石，於是他的人生越趨向下沉淪，如入深淵。

叔本華喜好印度哲學，他提出的解決方法就是印度式的《覺悟》所有的個體（人類、動物，Roger 提出的豬、狗、羊）都是慾望的意志表現，消除意志，便能從痛苦中解脫，所有的生物都只為了活下去而活，《Animals》探討意志是無限飢渴的存在，但現象界，卻是某種物理性的，有限度的世界，因此欲望永遠無法得到真正的滿足，欲望就像沙漏，永遠週而復始，倒過來又是滿滿的私慾了！想想慾望滿身的人類？我想聽完《Animals》每個人的心中自有思索。

## DOGS

### Musicians

Roger Waters: vocals, vocal harmonies, VCS3

David Gilmour: electric rhythm and lead guitar bass guitar, sound effects

Richard Wright: Hammond organ ARP solina piano Claviner, minimoog VCS3

Nick Mason: drums percussion

**Recorded**: Britannia Row, Islington, London: April - December 1976

**Technical Team**
Producer: Pink Floyd
Sound Engineer: Brian Humphries
ASE: Nick Griffiths

[Lyrics]
You gotta be crazy, you gotta have a real need
You gotta sleep on your toes, and when you're on the street
You gotta be able to pick out the easy meat with your eyes closed
And then moving in silently, down wind and out of sight
You gotta strike when the moment is right without thinking
And after a while, you can work on points for style
Like the club tie, and the firm handshake

A certain look in the eye and an easy smile

You have to be trusted by the people that you lie to

So that when they turn their backs on you,

You'll get the chance to put the knife in

You gotta keep one eye looking over your shoulder

You know it's going to get harder, and harder, and harder as you

get older

And in the end you'll pack up and fly down south

Hide your head in the sand,

Just another sad old man

All alone and dying of cancer

And when you loose control, you'll reap the harvest you have

sown（像得了狂犬病一般無可救藥）

And as the fear grows, the bad blood slows and turns to stone

And it's too late to lose the weight you used to need to throw

around

So have a good drown, as you go down, all alone

Dragged down by the stone (stone, stone, stone, stone, stone)

I gotta admit that I'm a little bit confused

Sometimes it seems to me as if I'm just being used

Gotta stay awake, gotta try and shake off this creeping malaise

If I don't stand my own ground, how can I find my way out of

搖滾哲思

this maze?

Deaf, dumb, and blind, you just keep on pretending

That everyone's expendable and no-one has a real friend

And it seems to you the thing to do would be to isolate the winner

And everything's done under the sun

And you believe at heart, everyone's a killer

Who was born in a house full of pain

Who was trained not to spit in the fan

Who was told what to do by the man

Who was broken by trained personnel

Who was fitted with collar and chain

Who was given a pat on the back

Who was breaking away from the pack

Who was only a stranger at home

Who was ground down in the end

Who was found dead on the phone

Who was dragged down by the stone

　　Roger Waters 用這部作品來隱喻並探討罪惡感，在 Roger 的想法中，耶和華擁有負面的樣貌，他唯恐我們誤入歧途，墮入罪孽，他把狗比論成社會中的社會階層，必須極盡討好老闆，

鞠躬哈腰（creeping）才能混口飯吃，否則就成了像街頭的流浪狗，如你不理會普羅階級的普世價值，你很快的就會被啃噬掉，而無法在這個社會生存下去。但是這些普世價值一再的侵蝕掉他們對自己的價值認定，在此同時自己因為心理的不平衡狀態，因此就像狗咬狗一樣，覺得自己也需要找個對象來責怪，並且藉此重新拼湊出已經四分五裂的自我價值，他們在社會裡學到的事是謊言，你爭我奪，互捅一刀，這樣的戲碼在社會的中層階級一直不斷的上演著，好像某些人也一樣要受到某種罪罰，這樣正義才可以繼續運轉著。但是如果社會沒有做到呢？Roger Waters 一向擅長做內心的探討，他連續提出了多項人生問題：

who was born in a house full of pain ?

who was trained not to spit in the fan ?

who was told what to do by the man ?

who was broken by trained personnel ?

who was fitted with collar and chain ?

who was given a pat on the back ?

who was breaking away from the pack ?

who was only a strangerat home ?

who was ground down in the end ?

who was found dead on the phone ?

who was dragged down by the stone？

　　這是一套批評與責難的戲碼，但，一定每個人都能展演於外嗎？如果不能呢？不論展演於外或在內在靈魂上演都是社會問題跟精神問題，內在的靈魂會試圖掙脫開來，以心理學上的術語來說就是「超我」（superego）他們會呈現出輕視、責難、推就、挑剔，將所有的一切投射到伴侶、父母、兄弟姊妹，或社會上的任何一個忍不住要投射的陌生人身上，而上演一場權力鬥爭。但是這樣的衝突很可能會癱瘓掉我們內在的整個靈魂，讓人變得消極，怠惰，情緒低落，覺得人生乏味，無法展望未來。這個超我反而會變得歉疚、罪惡感，覺得自己在這個社會是多餘的，如果他不做些什麼事的話，就會覺得自己像躺在病床上的人一樣，他會試著不斷向這個社會或是世界與之鬥爭試著向世界證明些什麼。

　　以馬斯洛的心理學來看這個中堅階層的人士，是社會上最為矛盾且內心最掙扎的一群人如果能以佛家的思想來看這樣的誡命，也許會好過一些，因為每個人來到這個世上都有他的誡命，這必需要透過內省的過程，人生中本來就有許多無法達成的，或無法完成的目標，還有不可能完成的期待，一步一步的走向自我的內省，這些問題其實是早期，我們各式各樣的權威所殘留下來的，而且是已經失去了生氣的過往經驗，就像秋天的樹上已經乾枯的樹葉，遲早要掉卜來的。

我們可以看一下布萊克（William Blake）的那幅畫作「尼布查尼撒」（Nebuchadnezzar）是英國浪漫派詩人與畫家，此畫作完成於 1795 年。如果我們在不知不覺中，變成眼中只見得到名氣，成就及地位的人，變得只願意從我們的職業角色或者只從我們牽涉的其中的團體、社會習慣，來汲取對自己的認同以及對社會組織的認同，那麼一旦這些社會組織開始變質，或者失去作用，我們就會感受到類似「從上帝的恩典中失寵」的經驗，但也是在這時候我們等於得到了一個契機，去學會如何重新將我們的能量導向榮耀我們的內在，從而我們也會以新的方式，重拾讓我們自己立基穩固的感覺，當我們首度遇上自己內心中的恐懼，發現自己對他人的輕蔑，以及對自己做出負面批評的時候，我們會感到羞愧，而無地自容，而我們需要學會認清這些，正是對自己無法自容的反應機制的一部分，並且記得自我接納，正是這趟自我探索的追尋目標，假如我們可以依循這樣的方式，一樣一樣的拆解這些反應過程，並且不施加壓力去強求或改變或轉化，我們就可能找到內在的自由，並且更能在這個形式框架構成的世界裡，覺得自在安適，而這其實就是真正的我。

紀伯倫說：「假如它是你想從王位上拉下的暴君，請先確立矗立在你內心裡的那張王座是否已經推倒了」，亦即我們要察覺到自己是如何有如一為暴君般，以負面的內心對白，以不可能達到的期待，來欺壓凌虐自己。

從這張專輯開始似乎就是 Roger Waters 世紀的開始，David 平常多以高音的技巧彈奏，在這首曲子被要求從 E 小調到 D 小調並以低音相較於以前的高音彈奏法大異其趣，但 David 仍很客氣地表示他願意配合完成此作品。

〈Dogs〉這首作品是以 David Gilmour 的空心吉他漸漸帶入，並採用雙軌錄製讓音色更飽滿成 stereo 立體聲的狀態聲音，從左至右由 Farfisa 機型錄成。

David Gilmour 是主唱仍維持著他高音的唱腔，只有吉他獨奏的部分調至低音處，在 1:50 秒的地方展開 solo。Roger Waters 維持著很有水準的 Bass 線條，Richard Wright 則創了和諧的音色，稱為 Generous B-3，音樂到了 3:00 時 Richard Wright 彈奏 solo 用的是 Minimoog 琴，而 David Gilmour 彈著節奏吉他使用的是否是 Black Strat 資料上則沒記載，但用 Leslie 的效果器來呈現效果非常棒，和諧的旋律及和弦到了 3:34 秒出現了第三隻吉他，由 Binson Echorec 彈奏，Nick Mason 的鼓在這首曲子裡力道十足可謂屈居要功。

**SHEEP**

Song by Roger Waters 10:19

**Musicians**

Roger Waters: vocals, vocal harmonies, VCS3

David Gilmour: electric rhythm and lead guitar bass guitar, sound effects

Richard Wright: Hammond organ ARP solina piano Claviner, minimoog VCS3

Nick Mason: drums percussion

**Recorded**: Britannia Row, Islington, London: April - December, 1976

**Technical Team**

Producer: Pink Floyd

Sound Engineer: Brian Humphries

ASE: Nick Griffiths

[Lyrics]

[Verse 1]

Harmlessly passing your time in the grassland away

Only dimly aware of a certain unease in the air

You better watch out

There may be dogs about

I've looked over Jordan, and I have seen

Things are not what they seem

[Verse 2]

What do you get for pretending the danger's not real

Meek and obedient you follow the leader

Down well trodden corridors into the valley of steel

What a surprise!

A look of terminal shock in your eyes

Now things are really what they seem

No, this is no bad dream

[Interlude]

(stone, stone, stone...)

The Lord is my shepherd, I shall not want

He makes me down to lie

Through pastures green He leadeth me the silent waters by

With bright knives He releaseth my soul

He maketh me to hang on hooks in high places

He converteth me to lamb cutlets

For lo, He hath great power, and great hunger

When cometh the day we lowly ones

Through quiet reflection, and great dedication

Master the art of karate

Lo, we shall rise up

And then we'll make the bugger's eyes water

[Verse 3]

Bleating and babbling we fell on his neck with a scream

Wave upon wave of demented avengers

March cheerfully out of obscurity into the dream

Have you heard the news?

The dogs are dead!

You better stay home

And do as you're told

Get out of the road if you want to grow old

　　〈Sheep〉這一個作品本來是在 1974 年時，他們創作原名為「Notting Hill Riots」在英格蘭表演時的曲名，後來收入《Animals》專輯改名為〈Sheep〉，跟〈Dogs〉一樣原先曾出現在 1974 年的法國巡迴演唱中，即使 1975 年他們創作〈Wish You were Here〉時一樣沒有想到把他列入專輯中。

　　Roger Waters 的婚姻告吹也在這張專輯巡迴演出的時候，當他打電話回家時竟然是一個男的來接電話⋯⋯他的第一個老婆 Judy Trim，可以說是他從小就認識的青梅竹馬。這次的經

驗後，讓他從此不再信任婚姻，後面的幾次婚姻也都已離婚收場，在《*The Final Cut*》及《*The Wall*》兩張自傳式的探討可以看出他對女人及婚姻的懼怕，Roger Waters 這方面的心理障礙我們在前面的章節中有深入的探討過。

我們就〈Sheep〉這首作品來看 Roger Waters 政治觀點，很顯然 shepard 牧羊人，在這裡指的並不是基督宗教上的那三位聖人，而是指政治階層裡掌控整個國家社會機制的政治人物，他們是霸權的，把它比喻為馬斯洛心理學家所分析的三角形的社會型態下最底層也是最大眾的一群，他們無法明辨是非，每天只要有青草可吃就一天過著一天。

現在的問題是，人們尤其是知識份子的內心需求比這些中下階層的人更為強烈，而中下階層的人民又是那麼的容易受鼓動而走上街頭抗議，當這個世界作為一個整體，而且人生必須應該要有意義時，究竟它的意義為何？這個世界又必須如何呈現出來，才能符合所賦予它的意義呢？如果現世的秩序本來就是依著個人的規律進行著理性化，那麼這個統一性的假設會更迫切地需要獲得實現。社會學家馬克斯・韋伯（Max Weber）對於人類想改變所處的社會歸納出看法，韋伯提出「預選說」，有一種理性的解說，尤其是印度的種姓制度只能以業障（karma）來解釋中下階層人民一生一世的果報，「業報說」對神人二元論有一種本體論的解釋，而韋伯的預選說對此二元論有一種倫理性的解釋，認為這是完美上帝與被創造的，罪孽

深重的世界間的對恃。個人的宗教命運則被視為上帝恩寵的賜物，從最後的結果來說，個人的善行或惡行根本無法影響上帝的決定。我們可以發現這種辯神論，若普遍被普羅大眾接受的話，不一定只強化了宗教的拒世動機，更可以有相當不同的實際後果，因為業報說所強調的是不去改變世界，而想從現世中解脫出來以逃避「再生再死」的永恆之輪。

韋伯描述這種業報說，對 Roger Waters 提及的社會上被歧視（sheep）及享受特權（pigs）的階級特別有其保守的影響，業報說對被歧視者而言，削弱了他們團結起來反抗制度的動機，因為唯有遵守這樣的社會秩序，才能獲得較佳的轉生機會，而對低階層的人，這種機會無疑是較有利的，韋伯寫到「當共產黨宣言以這種句子結束：他們無產階級了，除了他們的鏈鎖以外，沒有什麼可輸掉的，而他們可以贏得一整個世界」。他可以再生在與此世相同的秩序中，就像星辰運行與人獸之分一般的固定，因此想改變這些毫無意義，對社會的特權階級（pigs）這樣的理論根本取消了他們任何行動的動機，因為任何行動都會使靈魂重新陷入業報因果之中，反而危害了最後得救的目標。

業報說所強調的是不去改變世界，相反的，韋伯的「預選說」正是強調要以上帝之名，將世界加以支配，藉以證明自己榮獲了恩寵，在這恩寵中上帝憑著自由意志將他所創造的，重新給予改變的力量。

如果從韋伯的宗教觀點來看 Roger Waters 的〈Sheep〉對於政治領域內在的自身法則性這一個假設所做的反省，韋伯以一種行為本身在實踐上，不得不也考慮到以暴力作為手段（意指政治行為）來推演出這樣的論點，政治對他而言不等同於倫理，也不等同於經濟或技術，政治始終是由傾向於「以內在與外在權力分配之維持或改造作為絕對目的」的觀點所籠罩，雖然這並不是說政治便會完全被此一目的所吞沒，但是此一目的排除了將政治與倫理、經濟或技術完全結合的可能性。

　　今日的政治發展了一套形式與實質理性的辯證，價值、目的與手段間的辯證以及理論、實踐與技術間的辯證。

　　唯有當這些辯證過程是以自覺的形式出現，正方能站在時代尖端，這種意義下的政治必須塑造出責任倫理之態度為前提，唯有透過這種方式，現代的政治家們才能在現代西方理性主義的條件下，對現實有一種既非逃避現世也非適應現世的關係，而是以運用權力作為手段來實現理性的支配。威廉二世時代的德國在韋伯眼中，乃充斥了尋求適應眼前機會之官僚精神，Roger Waters 所隱喻（Pigs）應以此為行為之準則，此一現實政治之勢力如此龐大，對韋伯而言，也有一部分得歸諸於市民階級，及 Roger Waters 隱喻的 Dogs 與無產階級（Sheep）在政治上的「無能」因為農業與資本主義在實質和理念上的利益結合一塊，再加上一個光喊革命口號的無產階級，在在都給予一個反動政治以側翼支援（Wolfgang Schluchter）。

# The Pros and Cons of Hitch Hiking

## Chapter *10*

**——如果上天願意在你的生命中多贈與你 41 分鐘你想做什麼？**

　　《*The Pros and Cons of Hitch Hiking*》是 Roger 第一張離開 Pink Floyd 後的作品，其實他在 1979 年時，創作了兩張專輯，一張是《*The Wall*》另一張即是《*The Pros and Cons of Hitch Hiking*》。當時他問團員，這兩張選一張，來作為樂團以及他個人的專輯，於是團員們選了《*The Wall*》。而他就把《*The Pros and Cons of Hitch Hiking*》擱置多年才出版，出版年為 1984 年。

這張主要談的是中年危機，很難想像 Roger 會寫以這樣為主題的東西，他以搭便車及與車上的人之互動來構思整張專輯，病患想像自己與女乘客之間的通姦，但純為意淫。最早的版本甚至還有女人的叫床聲。之後修版則刪去從 4:30 到 5:12 分之間的雜念。

1983 年開始在三個錄音室進行這張專輯的錄製，並邀請許多音樂人參與，值得一提的是，第七首〈4:50 am (Go Fishing)〉和後來的《The Final Cut》〈The Fletcher Memorial Home〉使用的副歌是一樣的，〈Your Possible Past〉也使用了同樣的合唱旋律。1984 年的手板是雙黑膠，所以不得不在雙碟之間有一小段的空白，不過幾年後的 CD 版本，就成了連續性的接續法。

此張專輯的封面是由 Gerald Scarfe 所設計，他同樣設計了 Pink Floyd 許多唱片的封面，如《The Wall》。搭辯稱這張的封面引起了很多的爭議，因為他是一名色情女演員——Linzi Drew 的背面裸體圖，因此被一些女權團體所譴責。

吉他手 Tim Renwrek（此張專輯的主要吉他手），Roger 是個非常與眾不同的人，和 Eric Clapton 及 David Gilmour 不同之處在於，他不僅聰明有腦，對待自己的曲子總以嚴肅的態度看待之，因為當他巡迴演出時，他竟然要求團員也須依照與在錄音室時的彈奏法一模一樣。整張專輯圍繞著「中年危機」的主題繞。

Roger Waters 之後揭示本本來他做好了好幾首曲子在 1978 年本來想放到《*The Pros and Cons of Hitch Hiking*》（1984 年作品）然而他重新編曲後放到《*The Wall*》這張作品的開頭曲〈in the flesh?〉

Roger Waters 古老的夢想是希望 Yardbirds 的吉他手 Jeff Beck 能加入 Pink Floyd。而此希望也一度成了真——他在《*The Pros and Cons of Hitch Hiking*》請到了 Cream 的吉他手 Eric Clapton 參與。

1984 年的作品《*The Pros and Cons of Hitch Hiking*》從歌曲 4:30 到 5:11，共 41 分赤裸裸的呈現 Roger Waters 最黑暗的想法，這段時間 Roger Waters 看到了什麼？聽到了什麼？又做了什麼？經歷了什麼？人生起了什麼樣的變化？

Roger Waters 離團後的第一張個人作品，藉由剖析一趟引人入勝的旅程邂逅，抽象而隱約地露出人類複雜作用下的潛意識。Roger Waters 在作品中隱喻式的探討婚姻對於承諾忠誠度，以及中年危機的人性考驗。每一首曲子的標題皆以時間來標序，是 Roger Waters 自身經驗如夢似幻的夢境時序。

Roger Waters 請 Eric Claptain 情商客串展現了一貫的慵懶媚態，David Sarborn 的 Saxphone 在〈Go Fishing〉以及〈Pros and Corns of Hitch Hiking〉Part 2 和 Part 10 中展現了幾近懾魂般的吹奏魅力，封面全裸的女子背著旅行後背包，在男人的人生道路上比著搭便車的手勢，你是要搭載呢？還是要視而不見的掠過呢？

Roger Waters 假借了許多有名有勢的人的特力引誘其犯罪如 John Lennon 的老婆 Yoko Ono 她告訴故事中的主人翁，「跳入吧」，反正所有的人都會有毀滅的一天，又引用了 1930 年代的暢銷偵探連還漫畫 Dick Tracy[13] 裡的每天都有成出不窮的犯罪事件產生，以及一齣 1953 年長達一小時五十八分鐘的戲，探討 Enigmatic Gunslinger Shane 到了一個小鎮 Wyoming Town，Shane 陷入了小鎮的惡鬥中。以上這些出現在這張作品中，但 Roger Waters 什麼都沒碰觸，什麼都沒涉入，他僅止於腦中意淫，讓自己全身而退。這段從四點三十分展開的想像旅程終於至凌晨五點十一分清醒！

我們在這本書裡找出了這兩首 5:01 am 與 5:06 am，較與哲學思想相關的作品來探討。

Roger Waters 於 1984 年自組樂團名字為 The Bleeding Heart

團員都是他認識多年的好友，Roger 在 1984 年與此團做了《*The Pros and Cons of Hitch Hiking*》，但直到 1985 才離開 Pink Floyd。

這張專輯他請到了 Eric Clapton 情商客串演出 5:01 am 及 5:06 am，增加了許多的慵懶媚態。

---

[13] 1931 年開始連載的美國長篇偵探故事連載漫畫，於 1990 年被翻拍成電影。

**THE PROS AND CONS OF HITCH HIKING (5:01 am)**

**Musicians**

Roger Waters: bass guitar, rhythm guitar, tape effects, lead vocals

Eric Clapton: lead guitar, backing vocals, Roland guitar synthesizer

Ray Cooper: percussion

Andy Newmark: drums, percussion

David Sanborn: saxophone

Michael Kamen: piano

Andy Bown: Hammond organ, 12-string guitar

Madeline Bell, Katie Kissoon, Doreen Chanter: backing vocals

Raphael Ravenscroft, Kevin Flanagan, Vic Sullivan: horns

The National Philharmonic Orchestra, Conducted and Arranged by Michael Kamen

**Recorded**: February - December 1983

**Technical Team**

Roger Waters: producer

Michael Kamen: producer

Andy Jackson: recording, engineer

Laura Boisan: assistant engineer

[Lyrics] - 5:01am

An angel on a Harley

Pulls across to greet a fellow rolling stone

Puts his bike up on its stand

Leans back and then extends

A scarred and greasy hand, he said

Hells Angel: "How ya doin bro?...where ya been?...where ya goin? "

Then he takes your hand

In some strange Californian handshake

And breaks the bone

Angel's Moll: "Have a nice day "

A housewife from Encino

Whose husband's on the golf course

With his book of rules

Breaks and makes a 'U' and idles back

To take a second look at you

搖滾哲思

190

You flex your rod

Fish takes the hook

Sweet vodka and tobacco in her breath

Another number in your little black book

These are the pros and cons of hitchhiking

These are the pros and cons of hitchhiking

Oh babe, I must be dreaming

I was standing on the leading edge

The Eastern seaboard spread before my eyes

"Jump" said Yoko Ono

"I'm too scared and too good looking" I cried

"Go on," she says

"Why don't you give it a try?

Why prolong the agony

All men must die"

Do you remember Dick Tracy?

Do you remember Shane?

Joey: "And mother wants you"

Could you see him selling tickets

Where the buzzard circles over

Joey: "Shane"

The body on the plain

Did you understand the music, Yoko

Or was it all in vain?

Joey: "Shane!"

The bitch said something mystical "Herro"

So I stepped back on the curb again, wooh

These are the pros and cons of hitchhiking

These are the pros and cons of hitchhiking

Oh babe, I must be dreaming again

These are the pros and cons of hitchhiking

These are the pros and cons of hitchhiking

These are the pros and cons of hitchhiking

These are the pros and cons of hitchhiking

These are the pros and cons of hitchhiking

Yoko ono 出現兩次在 Roger Waters 的不同專輯裡其一是《Prons and Cons of Hitching Hiking》其二則是《Amuse to Death》他覺得 John Lenoon 對 Yoko ono 來說是一個很重要的精神伴侶，而對於 Roger Waters 來說 Pink Floyd 則是他的人生伴侶在他創作《Prons and Cons of Hitching Hiking》時正遭受第二次的婚姻破裂的時刻，我們可以從這張作品中窺見他面臨中年危機及婚姻破滅的傷感。

[Lyrics] - 5:06am
Waitress: "Hello... you wanna cup of coffee?"
Trucker: "Hey... Turn the fucking Juke Box down"
Waitress: "I'm sorry, would you like a cup of coffee?
Okay, you take cream and sugar? Sure"

[Verse 1]
In truck stops and hamburger joints
In Cadillac limousines, in the company of has-beens
And bent-backs
And sleeping forms, on pavement steps

In libraries and railways stations
In books and banks

In the pages of history

In suicidal cavalry attacks

[Chorus]

I recognize

Myself, in every stranger's eyes

[Verse 2]

And in wheelchairs, by monuments

Under tube trains and commuter accidents

In council care and county courts

At Easter fairs and seaside resorts

In drawing boards and city morgues

In award winning photographs, of life rafts on the China seas

In transit camps, under arc lamps

On unloading ramps, in faces blurred by rubber stamps

[Chorus]

I recognize

Myself, in every stranger's eyes

搖滾哲思

194

[Verse 3]

And now

From where I stand

Upon this hill

I plundered from the pool

I look around

I search the skies

I shade my eyes

So nearly blind

And I see signs

Of half remembered days

I hear bells that chime

In strange familiar ways

[Chorus]

I recognize

The hope, you kindle in your eyes

[Outro]

It's all so easy now

As we lie here in the dark

Nothing interferes, it's obvious how to beat the tears

That threaten to snuff out the spark of our love

　　這一張的製作人跟《*The Final Cut*》一樣請到 Michael Kamen，錄音工程則請到了 Andy Jackson 我想我們的生命就是一連串的選擇題，是要與草木同朽？遺臭萬年或是萬古流芳？但真正能萬古流芳的不是人的名，因為連名字都是虛幻的假合，人活著的真正價值就是對別人精神領域的影響力，這才是真正能永垂不朽，萬古流芳的資產，我們身而為人應該要留下來的是一些精神的文明、精神的資產，讓整個社會及後代子孫能享用，而人死後留了名，若能讓後人崇拜或是效法其行宜，固然很好，但是對自己本身來說，這一切早已灰飛煙滅，不復存在了。

　　調整與找到自己生命的定位，發揮生命的良知良能，自然而然就能產生利他的思考，轉化自己的私慾，沒有了恐懼自然會從內心升起愿心和愿力引領自己從煩惱中解脫，每一步、每一分每一秒都是自由自在的自由心證。

　　Eric Clapton 在《*Prons and Cons of Hitching Hiking*》中的表現，完全是由第一個因出現時即展開他的想像旅程而創作，整張專輯無論是 Roger 或 Eric 都充滿了鉅大的想像力，回到 80 年代，你可以想像，當時充斥著電子樂的音樂，每個人穿著運動衣在

街上跳著4/4拍子的舞，而這張作品是多麼的別異其趣。

這首由時間鎖序的作品，他作了許多年才完成，在 4:33AM 的〈Running Shoes〉有一片段好像是回到了《*The Wall*》的每一首曲子的一小段，這張專輯一樣不是讓人聽了很放鬆的作品，就跟他以往的創作一樣，壓力、張力，貫穿 41 分鐘。

2013 年的 7/26，他和 Eric Clapton 在北美為這張作品做了巡迴之旅。

這張作品從 4:30 的〈Apparently They were Travelling Abroad〉、4:33〈Running Shoes〉，4:39〈For the First Time Today (Part 2)〉整首作品沈浸在 Roger 的大喊「Stay with me」，加上音效提升了 Spiteful vehemence 這就是像另一張前衛搖滾 avant-grade，《*Prons and Cons of Hitching Hiking*》的創作來源是 Roger 自身在中東搭順風車到歐洲時的經驗作品，此專輯將此設想為夢境，具體的說 Roger 本身便是這 41 分鐘夢境的敘述者。

在 Eric Clapton 加入後之前，Roge Waters 早已將曲子做好，Michael Kamen 說道：「Roger 深知每一個人該如何彈奏，我想實際上，如果 Roge 可以，他一定會自己彈奏所有的樂器，Roge 已經把歌曲都鋪好了，沒有任何即興的空間」

人類因有夢想而偉大，行者因為有願力而得成就，創造擴展生命的威力，就在即刻當下自我心念的改變，即刻當下改變力量之大可以改變過去現在和未來（部分摘自曲吉囊覺上

師）這讓我有了一個思想，如果上天願在你的生命中多贈與你四十一分鐘，這多出來的四十一分你想做什麼？無論你做什麼？或不做什麼？都很可能將這個世界完全翻轉，也可能改變了整個歷史，混沌理論的蝴蝶效應（butterfly effect），一隻蝴蝶在葡萄牙舞動翅膀，可能導致墨西哥在數週後下起大雨，混沌理論無法解釋蝴蝶為何會引起雷雨，他解釋的是為何一個小原因可以迅速使未來的許多細小分子的位置，變得與這個小原因不存在時不同。這四十一分鐘只要你動了腦，動了念力，磁波可能震動了，因此猶大不出賣耶穌；動了眼，可能逮住了槍殺甘迺迪的兇手；動了口，可能改變了休莫（Hume）的矛盾率；動了心，可能改變了 Janis Joplin 的嘶喊，起心動念間世界因你而更美好！

《*Amused to death*》標題來自尼爾・波茲曼（Neil Postman）的書《娛樂至死》（*Amusing Ourselves To Death*），作品充斥訴說著懷疑論題，有時世界是反摺的，由內向外摺，他繼續探討著為何世界呈現如此狀態。

《娛樂至死》指出，現實社會的一切公眾話語，日漸以娛樂方式出現，並成為一種文化精神，我們的政治、宗教、新聞、體育、教育和商業都心甘情願地成為娛樂的附屬，其結果是我們成了一個娛樂至死的附庸。

《*Amused to Death*》是一張探討反戰聲浪，高張辯神論的

專輯。

　　1989 年電視播出了 64 天安門事件，一位穿著薄 t-shirt 的年輕人站立在街頭阻止了戰車進入鎮壓學生的場面。

　　人們是否都還記得這場面？還是已經忘得一乾二淨？

　　最糟的世界回憶錄是越南與越共的戰爭，美軍經歷了前所未有的恐懼，以英雄主義立國的美國，加入了越戰，當時反戰聲浪高舉，電視每天播著反越戰的抗爭遊行。

　　波斯灣戰爭，為 choreographed war 編舞的戰爭，阿拉伯世界與伊拉克的戰爭，政治與文化的衝突，西方文明所謂的對與錯在這裡全部翻轉了過來。

　　The Bleeding Heart Band 仍舊是 Roger Waters 的樂團，1992 年柏林圍牆倒塌，這個樂團在柏林演出，1992 年被認為是 halcyon era（平靜而美好的一個世紀的開始）

　　Pat Leonard 幫 Madonna 作曲，在這張專輯裡他參與了 keyboard 的演出。

　　Bob Ezrin 製作了 The Wall 及 A Momentary Lapse Of Reason，及 Radio Kaos。

# 參考書目

Blake, Mark, *Pigs Might Fly: The Inside Story of Pink Floyd*, London: Aurum Press, 2007 updated 2013, published as *Comfortably Numb: The Inside Story of Pink Floyd* in the US.

Christgau, Robert, *Christgau's Record Guide: The '80s*, New York: Mariner Books, 1981.

Du Noyer, Paul, *In the City: A Celebration of London Music*, London: Virgin Digital, 2009.

Fitch, Vernon, *The Pink Floyd Encyclopaedia* (3rd edition), Collector's Guide Publishing, Inc., 2005.

Fitch, Vernon, *Pink Floyd: The Press Reports 1966-1983*, Collector's Guide Publishing, Inc., 2001.

Guesdon, Jean-Michel and Margotin, Philippe, *Pink Floyd All the Songs: The Story Behind Every Track*, Black Dog & Leventhal, 2017.

Harris, John, *The Dark Side of the Moon: The Making of the Pink Floyd Masterpiece*, Cambridge, Massachusetts: Da Capo Press, 2005.

Reisch, George A. ed., *Pink Floyd and Philosophy: Careful with that Axiom, Eugene!*, Open Court, 2017.

Thompson, Dave, *Roger Waters: The Man Behind the Wall*, Backbeat Books, 2013.

Wild, Andrew, *Pink Floyd: Song by Song*, Fonthill Media, 2017.

## 哲學書目

尚－雅克·盧梭著。袁筱一譯。《一個孤獨漫步者的遐想》。臺北：自由之丘，2017年。

尚－雅克·盧梭著。《社會契約論》。臺北：商務，2018年。

馬丁·布伯著。《我與你》。天津：天津人民出版社，2018年。

富增章成著。徐雪蓉譯。《占星求神不如問哲學：向古今 60 位最重要哲學家思考，從愛恨生死柴米油鹽到人生根本，所有問題通通有解！》。臺北：三采文化，2017年。

郜元寶編。《尼采在中國》。上海：上海三聯書店，2001年。

┌─────────────────────────────────────────┐
│ 國家圖書館出版品預行編目                      │
│                                          │
│ 搖滾哲思 / 吳騁締, 敖采渝著. -- 臺北市：致出    │
│ 版, 2019.01                               │
│     面；　公分                             │
│   ISBN 978-986-96827-5-6(平裝)            │
│                                          │
│   1.搖滾樂 2.藝術哲學                       │
│ 910.11                      107023633    │
└─────────────────────────────────────────┘

# 搖滾哲思

**作　　者**／吳騁締、敖采渝

**出版策劃**／致出版

**製作銷售**／秀威資訊科技股份有限公司

　　　　　　114 台北市內湖區瑞光路76巷69號2樓

　　　　　　電話：+886-2-2796-3638

　　　　　　傳真：+886-2-2796-1377

**網路訂購**／秀威書店：https://store.showwe.tw

　　　　　　博客來網路書店：http://www.books.com.tw

　　　　　　三民網路書店：http://www.m.sanmin.com.tw

　　　　　　金石堂網路書店：http://www.kingstone.com.tw

　　　　　　讀冊生活：http://www.taaze.tw

**出版日期**／2019年1月　　**定價**／300元

# 致 出 版

向出版者致敬